T0317781

Human Rights Watch Ed Kashi

Ronald Grätz and Hans-Joachim Neubauer (Eds.)

Human Rights Watch
Struggling for a Humane World
Interviews

Ed Kashi
Sugar Cane
Syrian Refugees
Photographs

Steidl / ifa

Contents

Foreword

Ronald Grätz and Hans-Joachim Neubauer

What is worth fighting for? What should hold true for everybody? Which philosophical or social visions should shape our age? And what should the future look like? Human Rights Watch stands for a radical answer to these questions. Without human rights there is no future. That is what is worth fighting for.

After the end of World War II human rights became the most important item on the agenda of the world community. Numerous statements of principles, speeches, and debates, and influential political bodies right up to the United Nations High Commissioner for Human Rights, all led to real agreements and rules between and within states. Politics took this subject seriously. But that was not enough.

Human Rights Watch (HRW) is one of the organizations that have understood that the well-being of ordinary people cannot be left to politicians alone. To ensure this, Human Rights Watch has more than four hundred staff worldwide—lawyers and experts on the political, cultural, and social affairs of all the different countries around the world. With the support of countless further specialists and volunteers, Human Rights Watch campaigns for the end of discrimination, corruption, torture, and the death penalty. They fight for press freedom and the self-determination of women, they denounce war crimes, wrongful state surveillance and interventions, and they work for the protection of children in war areas. In 2016, the Institut für Auslandsbeziehungen (ifa) awarded the Theodor Wanner Prize to Human Rights Watch for its wide-ranging and effective commitment. The prize money of ten thousand euros was provided by the Klett Group.

This was the first time that the Theodor Wanner Prize was given to an organization. With this prize, the Institut für Auslandsbeziehungen honors personalities who have worked as outstanding promoters of dialog

between cultures and for peace and understanding. The first prizewinner was Daniel Barenboim in 2009. In 2010 Carla Del Ponte received the prize, in 2011 Jacques Delors, in 2013 Yoko Ono, and in 2014 Ernesto Cardenal. Now, the Institut für Auslandsbeziehungen has purposely decided to award the prize not to an individual but to an organization. This will not only support the work of Human Rights Watch on the ground, but can help to promote an idea for which so many people work with such great commitment. It is not just the big names that advance dialog between cultures, and not only famous people who are fighting for better lives and perspectives for ordinary people. The work of Human Rights Watch shows how much commitment is really needed, in terms of money and effort, and, not least, how many people are required to make progress in human rights. Human Rights Watch is financed exclusively by donations from private individuals and foundations. Any support from states is strictly out of the question.

The charitable US organization Human Rights Watch was founded in 1978 as Helsinki Watch. It gained its present name in 1988 through a merger with several other internationally active aid organizations. Human Rights Watch produces more than a hundred reports and briefings on over ninety countries annually, pointing out threats to human rights worldwide. Working closely with local and regional activists and human rights groups, Human Rights Watch staff collect the information that forms the basis of their reports. This research is especially thorough, as shown by the great respect that the work of Human Rights Watch receives from the international community. A lot of its work takes place away from the public eye—Human Rights Watch seeks out dialog with governments and representatives of states, with the United Nations, and with regional organizations such as the African Union or the European Union. Human Rights Watch also has close contact with financial institutions and businesses, aiming to promote the economic conditions that can help to practically improve human rights.

This book on Human Rights Watch, with Ed Kashi's photo reports *Sugar Cane* and *Syrian Refugees*, is the fourth volume by the Steidl publishing house presenting Theodor Wanner Prize winners. It follows Carla Del Ponte's *Mein Leben für die Gerechtigkeit* (My Life for Justice)

with the photo essay *Wer entscheidet?* (Who Decides?) by Robert Lyons, Jacques Delors' *Mein Leben für Europa* (My Life for Europe) with photos by Carl De Keyzer (EVROPA), and Ernesto Cardenal's *Mein Leben für die Liebe* (My Life for Love), with Susan Meiselas' photo essay *Nicaraguita*.

An interview is always both a portrait and self-portrait at the same time. The idea of presenting an institution like Human Rights Watch through the medium of the interview is especially attractive. We were fortunate to be able to speak with three people who see Human Rights Watch from three very different perspectives.

Kenneth Roth has been the Executive Director of Human Rights Watch since 1993 and is thus one of the most informed people in the world when it comes to human rights. He explains how his organization operates and negotiates the range of interests of both local protagonists and supranational institutions. He shows what his work means to himself personally, and he clearly points out the effort that needs to be made to defend human rights at a time that is shaped by the consequences of climate change and by increasing inequality and religiously motivated violent conflict.

Zama Coursen-Neff, Executive Director of the Children's Rights Division at Human Rights Watch, co-chairs the Global Coalition to Protect Education from Attack (GCPEA). She tells of the dangers when schools and universities in war zones are occupied and used for military means, and she reports of successes in the fight against this. Human Rights Watch has given the Theodor Wanner Prize money to the GCPEA.

In 2010, George Soros gave Human Rights Watch one hundred million dollars. In our interview, the billionaire, philanthropist, and writer explains why he chose to donate such an enormous sum to this organization. He also details what has to happen to achieve large-scale improvement in human rights.

Ed Kashi's photographs show what it is like when people's rights are abused. The American photojournalist is well known for his provocative reports from many places around the world. Whether he is portraying the situation of Kurds, reporting on the oil industry in the Niger Delta,

9

Protestants in Northern Ireland, or Jewish settlers in the West Bank, Kashi's photographs repeatedly take a new look at reality as it is experienced by real people. For more than twenty years, he has been working closely with the National Geographic Society, and his photos are featured in *GEO*, *The New York Times Magazine*, *Newsweek*, *Time*, and other well-known media.

In his photo essays *Sugar Cane* and *Syrian Refugees*, Ed Kashi looks at two key themes of our time—uncompromising exploitation under the sign of global capitalism and the lives of refugees. Kashi's pictures of sugarcane laborers show the price that people in Nicaragua and San Salvador are paying so that customers from the Global North can cheaply sweeten their lives. In his pictures from refugee camps in the Middle East, Kashi shows the efforts that Syrian refugees are undertaking to create some kind of normality under the most unfavorable conditions. Ed Kashi's photos are more than just optical records of reality. Every one of them is full of the empathy of a photographer and the precision that has made Kashi so well known. "What will become of these children when they grow up?" he asks, and he demands: "We have to take care of them if we want to break the cycles of violence and exert a positive influence." Photography can mean pursuing a mission, a mission on behalf of people. For their rights.

Translated from the German by Greg Bond.

Human Rights Watch

Struggling for a Humane World

Interviews

"No religion has a monopoly on good or evil"

An interview with Kenneth Roth, Human Rights Watch

The Situation Today

The chances for a more peaceful world seem to be poor: climate disasters, floods and periods of drought are on the increase, and there will be ever more and bigger conflicts about water, food and security. What has to happen to deescalate this situation? Who has to take action?

Climate change is creating pressure for large-scale displacement and aggravating conflict over scarce resources. The way governments respond to these pressures can mitigate or increase the human suffering they cause. Worst-case scenarios are situations such as Syria today or, beginning a decade ago, Darfur. In each case, climate change may have contributed to conflict by displacing people and intensifying pressure for scarce resources, but the government's horribly abusive response massively escalated the crisis and its deadly impact. Climate change did not cause the government of Sudanese President Omar al-Bashir to unleash the Janjaweed to viciously attack the non-Arab residents of Darfur. Nor did it have anything to do with the decision by the government of Syrian President Bashar al-Assad to fight an armed insurgency by attacking civilians and civilian institutions in areas that had been taken over by rebel forces. These war-crime strategies were the product of particularly ruthless governmental leaders, not climate change. That's why it's important for us to insist that in responding to climate change governments respect international human rights and humanitarian law.

International human rights law also provides a useful guide for positive action as governments look to adapt to the challenges of climate change. Concepts such as the right to water, health, or a livelihood

mean in essence that as governments plan to spend available funds to help their citizens adapt to the rigors of climate change, they should focus on the most vulnerable, worst-off segments of society, where the need is most acute.

What do you expect and what do you hope from the BRICS states?
In addition to addressing abusive governments directly, Human Rights Watch has a long tradition of trying to enlist powerful Western governments to promote human rights around the world. However, in recent years, as the relative influence of Western governments has waned and they have lost some of the moral high ground, we have also looked to regional powers such as the BRICS states, with their growing economic clout, to supplement Western efforts. However, none of them has an established tradition of promoting human rights abroad, and their willingness to assume such a role varies considerably.
The most positive has been Brazil, which often supports human rights initiatives at the UN Human Rights Council. It joined with Germany as a lead defender of the right to privacy from digital surveillance. However, it has refused to criticize repressive practices in countries such as Cuba and Venezuela, citing the principle of non-interference. Its fear of doing anything that might lead to military intervention (after the disasters of Iraq and Libya) has also led it to pull its punches even in the face of atrocities in Syria.
India and South Africa, both vigorous if flawed democracies at home, are more reluctant to promote human rights abroad. There have been exceptions: South Africa is a strong defender of the rights of lesbian, gay, bisexual, and transgender people, and India at certain key moments (largely for domestic political reasons) supported efforts to secure accountability for Sri Lankan war crimes. But more often India and South Africa eschew promoting human rights because of more immediate political interests or out of an outdated sense that it is neo-colonial or imperialistic to seek to improve the rights of people in other countries—as if people elsewhere don't deserve the same rights as their own citizens.
Russia and China are on a different plane. Under both Vladimir Putin and Xi Jinping, these governments have become increasingly repressive as they try to snuff out any organized criticism of their rule. China even

extends these efforts overseas, pressuring other governments to forcibly return refugees who have criticized Beijing, intimidating Chinese activists, and increasingly undermining academic freedom and freedom of expression online. Russia and China are both reflexively hostile to most international human rights initiatives. As demonstrated by their multiple vetoes to block even simple condemnations of atrocities in Syria, they are willing to use their power as permanent members of the UN Security Council to shield serious human rights abusers, whether Syria, Sudan, Burundi or Burma. Indeed, Russia has provided active military support to Syria without insisting that the Assad government end its systematic killing of civilians. China uses checkbook diplomacy with abusive governments without regard to the impact on human rights practices in those countries.

It's worth noting that while many people focus on the BRICS, other rising powers also have the potential to promote human rights in their foreign policies. Regarding Human Rights Watch plans for the future, we are looking to increase our capacity to enlist in this effort such governments as South Korea, Indonesia, Nigeria, and Mexico.

To keep violence under control, what must the world order look like? Do we need to redistribute wealth?

Economic and social rights, which are part of the internationally recognized canon of human rights, impose a duty on government to use available resources to progressively meet basic needs such as the rights to health, education, and housing. In that sense, international human rights law helps to point the way toward a more just distribution of wealth. The law does not require ensuring that no one is poor, but it does require governments to work progressively toward meeting everyone's basic needs.

A more just world would certainly have a fairer distribution of wealth. At the same time, abusive violence is rarely if ever simply the product of poverty. Syria was a middle-income country, but that didn't stop Assad from embarking on the mass slaughter of civilians who happen to live in opposition-held territory. Many of the people attracted to the Islamic State (or ISIS) were not led there by poverty, but by limited opportunities to meet their middle-class expectations.

There are millions of refugees in the world today. The situation is especially bad in the Middle East. The legacy of the Arab Spring is destabilization, refugees, expulsions, and failed states. Are despotic regimes ultimately better than civil wars?

With the exception of Tunisia, the Arab Spring has not turned out well, but there is no single explanation. In Egypt, the army's refusal to countenance a government led by the Muslim Brotherhood has yielded the most repressive rule (under Abdel Fattah al-Sisi) in Egypt's modern history. In Libya, Muammar Gaddafi deliberately maintained weak governmental institutions so they could not threaten his dictatorial rule, but when NATO helped Libyans to overthrow him, it didn't provide the long-term support needed to build effective institutions, leaving the current chaos. In Yemen, the US, UK, and France have backed the Saudi-led effort to fight a Houthi rebellion even though the casualties of coalition airstrikes too often have been civilians rather than Houthi fighters. And in Syria, the Assad government responded to an initially peaceful uprising with such brutality that the country has devolved into a deadly civil war.

In the short term, it is easy enough to say that the enforced order of repression is better than complete chaos, but repression is not a long-term solution. People naturally aspire to a government that respects their rights and enables them to democratically influence its direction. Rather than blame the symptom—the act of rebellion against tyrannical rule—we should focus on the original cause, the dictator and his autocratic rule. Creating accountable governments that respect the rights of their people is the best route to lasting stability.

The major powers and Europe are being increasingly drawn into the conflict in Syria. Russian bombers are attacking the rebels, Turkey is robustly defending its interests, US military advisors are operating in Latakia, and after the Paris attacks the French began their bombing missions. Do we already have a proxy war in the Middle East?

Syria has long represented a proxy war between Iran and Saudi Arabia (the latter joined by Turkey and various Gulf states), or, broadly speaking, between Shia- and Sunni-led governments. Russia has certainly

backed Assad as well—politically, by providing arms, and more recently with military force—while the Western governments have supported some rebel groups fighting Assad but have increasingly focused their efforts against ISIS. It is unlikely that the Syrian conflict can be resolved without taking these broader interests into account. So far international efforts to stem the fighting have treated the issue as one mainly of diplomacy, as if all that really matters is what might take place at the negotiating table. But it is difficult for the Syrian opposition to make the compromises that will be needed with a government that is systematically killing its families. It would advance the peace effort considerably if more effort were made to stop the Syrian government's indiscriminate slaughter of civilians.

Can arms really bring about peace?
We should certainly be suspicious when a government's first step toward "peace" is to go to war, but at the same time we should be careful about concluding that pacifism ensures peace. Quite apart from the fact that there will always be aggressive governments willing to take advantage of the weak, there are specific circumstances when a military response may be the only realistic option to avoid mass slaughter. Awful as war is, a government's deliberate, large-scale killing of ordinary people can be even worse. In the case of the Rwandan genocide, for example, it is quite likely that hundreds of thousands of lives could have been saved had the West mustered even a modest military response to the government's initial steps toward genocide.

States like Afghanistan and Libya have become highly dangerous areas in the wake of significant military interventions by the West. What should the international community do to promote peace there?
Afghanistan and Libya have in common that Western military interventions overthrew a dictatorial government, but from there their fates differ considerably. In Afghanistan, the West made an enormous effort to build state institutions. There has been some important progress in enabling a stronger civil society and securing better respect for the rights of women, but this "nation-building" exercise is far from complete, particularly since it has often relied upon abusive warlords and militia

that were never brought under the rule of law. In Libya, little effort
was made to build the institutions left in rudimentary form by the over-
thrown Gaddafi government, so today chaos reigns.

What chances do you see for the idea of the nation state?
Perhaps paradoxically, the human rights movement sees the state as
both the source of human rights violations and a necessary guarantor of
rights. As the paramount power in society, the state should be restrained
to respect rights, lest it be tempted to engage in prohibited conduct—
such as torture, censorship, or unjust imprisonment—to secure what it
wants. But the state is also needed to create the conditions in which rights
can be enjoyed—by maintaining public order through its police, and
establishing the rule of law through its courts. There is much talk of the
decline of the state in the face of powerful international forces, whether
multinational corporations, the global market, or the ease of commun-
ication among people, but none of that replaces the state's important
role as a protector of human rights.
As for the "nation state," it is important to unpack what that means.
If the "nation state" is simply synonymous with the "state," then the con-
cept is not problematic because all citizens can assert their rights
regardless of background. But if, as often occurs in Europe, the idea of
a "nation" embraces people of only a certain ethnicity (or religion),
then it can be a dangerous concept, because more than ever in today's
world of considerable mobility, the idea of a state based on a partic-
ular ethnicity can only encourage discrimination and marginalization.

Human Rights Watch – the Profile of an Organization

Where do you see the most important areas of operation for HRW right now?
Human Rights Watch works regularly in some 90 countries, so even
when the world may be focused on certain headline issues, we
are also doing important work in other areas. Naturally, we cannot help
but focus on the areas where there is widespread bloodshed, such
as Syria, Iraq, Yemen or Libya, or places where there is enormous poten-

tial for such bloodshed, such as Burundi, the Central African Republic, South Sudan, or the Democratic Republic of Congo, as well as on the flow of refugees from these crisis regions. We also are very focused on powerful states like Russia or China that are playing a nefarious role at home and abroad. And we don't ignore rights violations by Western democracies in Europe and North America. That said, we are doing very important work on less attention-grabbing issues, such as curtailing child marriage, protecting the rights of migrant workers, and defending the rights of lesbian, gay, bisexual, and transgender people.

How exactly do you operate when there is a crisis?

Although we address human rights abuses around the globe, we are modest in size, with a full-time staff of 420. That means in any given country we typically have only one or two staff engaged in research and writing about human rights abuses. That is a difficult task in ordinary times, but when a country explodes, it becomes impossible. For that reason, we have a small team of emergency researchers whose job is to be deployed in crises to help the overwhelmed researchers who usually address rights issues in the country. We have also developed a similar surge capacity on the advocacy side to ensure that the information collected on the ground is deployed to the capitals that are most likely to act on it. This emergency response enables us to move very quickly in a crisis, when the possibility for saving lives is greatest.

How long does it take to move from analysis to action?

A basic rule at Human Rights Watch is that we don't speak until we know what we're talking about. Even in a crisis, we must make sure to con-duct our research and understand what is happening before publishing our findings and seeking solutions. Fortunately, because we typically already have researchers on the ground with years of knowledge and experience, we do not operate on a blank slate. That history of involvement enables us to understand and respond to a changing situation quite rapidly—certainly within a matter of days, at times within hours.

How does HRW make decisions?

Human Rights Watch operates under a philosophy that I have actively promoted—that the people who are most knowledgeable about a

situation are the ones who are most likely to make the best decisions. As a result, we strongly defer to expertise. Our researchers are often the world's experts on their country or issue, so we naturally want them making most of the decisions about which human rights problems to address and how best to respond. The same goes for advocates in important capitals around the world—they know how best to approach a government to successfully enlist it on behalf of a human rights concern.

None of this is to say that Human Rights Watch staff are fully autonomous. Senior staff review the approaches recommended by researchers and advocates to ensure that they are wise, sensible, and consistent with international human rights and humanitarian law, and reflect the organization's principles of impartial promotion of human rights for all. Every report and news release is reviewed by several specialists; we must be extremely careful with every word we publish. But that review is carried out with a presumptive deference to the expertise of our most knowledgeable colleagues, which we believe is the most effective way to operate.

How hierarchical is HRW? How participatory?

Because of this deference to expertise, Human Rights Watch operates as a fairly flat organization, with each person largely responsible for making decisions in his or her domain. Still, there is a hierarchy—people who direct teams, whether of researchers, advocates, communications experts, or even fundraisers. That hierarchy is important for training, coordination, and quality control.

The organization is highly participatory. We encourage people to voice disagreements, because open debate is the best way to ensure a wise decision. And it would probably be futile to operate any other way, because Human Rights Watch is filled with strong advocates who usually direct their advocacy toward abusive governments but hardly stop being advocates when it comes to debating an issue within Human Rights Watch.

Work like yours needs clear decisions and structures. How do you make sure you have the commitment of your staff?

I find the most important way to secure the commitment of the staff is to give them ownership of their work. When staff members feel that they are foremost responsible for a country or issue—not that they are mere cogs in the wheel but that they have front-line responsibility— they are most likely to give their all. So in that sense our deference to expertise also can be motivational. Of course, it is still important to establish clear parameters within which staff operate. That is needed both to ensure organizational integrity and to provide basic guidance to the staff. Our most important principles demand scrupulous and impartial investigation and reporting of the facts, analysis of those facts under the requirements of international human rights or humanitarian law, and aggressive deployment of information to journalists and policymakers to maximize our ability to defend people's rights. Part of my job is to ensure that those principles are deeply engrained within the organization's culture.

HRW looks at the worst crimes against humanity. What do you advise a member of staff if he or she feels that the stress of this kind of work is just too much?
Human rights work is clearly not for everyone. It can be enormously rewarding to help people facing severe repression or abuse, but it can also be emotionally draining to repeatedly hear stories of personal suffering. We all try to focus on the good we can do, but it can be difficult to encounter day after day the evil that some people are willing to commit. In some ways our work is like that of a doctor who faces illness day in and day out, but keeps going because of the ability in at least some cases to cure people or make their lives better. But our work can be more difficult than medical work, because the ills we confront are not the vagaries of nature but the atrocities and abuse inflicted by some people on others. To combat the risk of stress and burnout, we do encourage staff to maintain a healthy work-life balance and to take time off when necessary.

Do you offer your staff psychological support?
Yes. We have retained a psychologist with expertise on the kinds of trauma that Human Rights Watch staff might face, so staff can always

quickly consult with a knowledgeable and experienced counsellor. Our health-insurance plan also allows more in-depth follow-up with psychological experts of the staff member's choosing.

In what ways do you work with other NGOs—in research and analysis, for example?

Human Rights Watch is part of the human rights movement, and virtually everything we do is done in partnership with other nongovernmental organizations. Our foremost partners are the local human rights groups and activists that today can be found in all but the most closed and repressive countries. As people immersed in their society, they have expertise that is essential for helping us to identify the most important issues to address, conduct the research, and craft an advocacy strategy. They are also the most at risk when governments try to silence the messenger about abuse, so we place a very high priority on trying to protect our partners.

Do you deploy to the same places as other NGOs?

The only international human rights organization with comparable coverage to Human Rights Watch is Amnesty International. Both of us work in most situations of abusive war or repressive government. We are very close partners, almost always pushing in the same direction, although each with our own tools and methodology. Amnesty's great strength is its mass membership, and much of its work seeks to mobilize that membership to press for respect for rights. Rather than replicating Amnesty's mass membership, Human Rights Watch has developed a parallel methodology focused on shaming abusive governments in the media and enlisting powerful governments to exert pressure on abusive governments to change their ways. Neither of these methodologies is exclusive; we both do some of each, but the distinction helps to understand the main difference of focus between the two organizations. The combination of Amnesty and Human Rights Watch can be a very strong one-two punch.

Do you have the same sources of information? Or do you have your own independent network of information providers?

A bit of both. We certainly share sources of information but we also conduct our own investigations, which is important, because that way our reports corroborate—rather than simply repeat—each other.

In what ways do you make contact with supra-state organizations like the High Commissioner for Human Rights or the International Criminal Court? How would you describe your work with them?
Just as we work with powerful governments to enlist their influence to promote human rights, we work with multinational and international institutions, both the United Nations and regional bodies such as the European Union, the African Union, and the Organization of American States. Sometimes these institutions are simply important forums where the governments of the world or a region convene to address common concerns. When the European Union acts, for example, that is more powerful than a similar action by an individual member state. At the United Nations, the intergovernmental bodies that we pay most attention to are the Security Council, which is empowered to deploy peacekeepers and other forms of international action to stop mass atrocities, and the Human Rights Council, where serious human rights problems can be investigated, reported on, and condemned. In all of our UN activities, we work closely with the UN High Commissioner for Human Rights. His office is able to deploy human rights observers and investigators in trouble spots, report his findings to the Human Rights Council, and add his important voice of condemnation or concern. We regularly share information, analyses and strategies.
As for the International Criminal Court, we were deeply involved in its creation, fending off efforts by various powerful governments that were unhappy with a tribunal that might force them to hold to account their own or allied abusive officials. We now work closely with the court as an important tool for combatting the impunity under which mass atrocities flourish. Our investigations and reports are a source of evidence for the court's prosecutor as she pursues cases. Our researchers serve as formal witnesses and informal advisors. And when abusive officials such as Sudanese President Bashir try to evade its reach, we work closely with local groups to help generate political pressure for arrest or compliance with its orders.

You see yourself as an independent organization. You do not allow states to finance you. Your work is based entirely on private donations. George Soros gave HRW 100 million US dollars in 2010. What influence does he have on your work?

A key source of our independence is our refusal to accept any government money. We would lose credibility if we had to think twice about criticizing a government because it might withdraw its support, so we avoid putting ourselves in that position by not taking any government money in the first place. That policy has made us a much stronger organization.

Our private supporters are spread around the world. The diversity of our funding is another source of our independence. Many people contribute to us with enormous generosity but George Soros, of course, stands out: As you note, he pledged 10 million dollars a year for ten years, representing today about twelve percent of our annual revenue of 80 million US dollars. Soros's gift did not come out of the blue. He had already been supporting us for more than 25 years when he made his extraordinary pledge. That means he fully understood the principles under which we operate, including our independence. It would have made no sense for him to invest so generously in a way that betrayed those principles. So while the pledge has been very important in helping Human Rights Watch build a truly global organization, Soros has never—before or after—sought to influence our research or advocacy. He believes in our principled independence.

In 2014, Nobel Peace Prize winners Adolfo Pérez Esquivel and Mairead Maguire criticized HRW for being too close to the US government. In an open letter they and many supporters wrote of a clear "conflict of interests" deriving mainly from the proximity between the US State Department and HRW. They spoke of a "revolving door policy". Were you surprised by this criticism? How did you react? How sure are you of your independence?

This particular criticism was generated by a group of academics who published things of this sort every time we criticized the Venezuelan government of Hugo Chávez or Nicolás Maduro. They wanted to suggest that the only reason we criticized Venezuela's repression is

because Washington did. The criticism makes no sense. A quick check of our website will show that we routinely criticize not only human rights abuses committed by the US government—Guantanamo, torture, drone attacks, police abuse, racial discrimination, and the like—but also US policy that is too supportive or tolerant of other abusive governments, such as Egypt, Saudi Arabia, or China. In fact, we are among the harshest and most vocal critics of both aspects of US conduct, and have, for example, pressed for an investigation of former President George W. Bush's authorization of torture. This hardly reflects a cozy unwillingness to challenge the US government. When we criticize Venezuela, we are applying the same methodology as we use around the world, including in the United States and with US allies.

As for the Human Rights Watch staff, I have never precluded us from hiring former employees of any government, because those people are sometimes in the best position to influence that government. For example, our Brazil director used to be the chief human rights legal advisor to the Brazilian president. Her knowledge of the workings of the Brazilian government and her access to the key decision makers have made her a powerful and effective leader of our work in Brazil.

The critics you mentioned were particularly concerned with Tom Malinowski. He had been President Bill Clinton's chief foreign policy speechwriter before joining Human Rights Watch as the director of our Washington office. He spent 12 years with us and was extraordinarily effective—one of the smartest, most articulate, most strategic advocates that we had. He then went on to serve as President Barack Obama's leading human rights official at the State Department, where he has continued his advocacy for human rights from inside the government. We believe that his years of experience in government made him a more effective advocate for our cause, while his years of service at Human Rights Watch are making him a better government official today.

The independence of our work is evident in our criticisms that we make of diverse governments that commit abuses and their supporters regardless of their political stripes. In this case, the charge of a so-called "conflict of interest" really appeared more to be an attempt to discredit our reporting on a repressive government, Venezuela, that this group of academics wanted to paper over.

What was the greatest success in the history of HRW?

This is an impossible question to answer. Typically people cite our role in creating certain international standards or institutions. We shared the Nobel Peace Prize for our leadership in the coalition to ban anti-personnel landmines. The treaty we helped to secure has so stigmatized these indiscriminate weapons that very few governments or armed groups use them anymore. We had similar successes securing treaties to ban cluster munitions, to end the use of child soldiers, and to establish the International Criminal Court.

However, most of our successes are more local. For example, our research demonstrating that Rwanda was providing military support to a ruthless armed group, the M23, in eastern Congo led to intense international pressure for it to stop. Within 48 hours after the Rwandan government finally acquiesced, the M23 crumbled, leaving a significantly safer eastern Congo than had been the case for years. Our work alerting the international community to the real possibility of imminent mass killing in the Central African Republic helped to convince initially France and the African Union to deploy emergency peacekeepers and later the UN Security Council to deploy a UN peacekeeping force of 12,000, averting what could have been huge loss of life. Perhaps less dramatically, our work has been central in convincing Malawi to curb child marriage and to stop prosecuting people for same-sex conduct. There are countless such successes to which Human Rights Watch has contributed.

And the biggest failure?

Perhaps our biggest unmet challenge is countering the very negative role that China is playing in the world. China represents a model of authoritarian economic growth that has obvious appeal to the dictators of the world, even though unaccountable rule is far more likely to lead to corrupt stagnation than economic growth. Much of China's economic growth is also due to the fact that Beijing finally unleashed the economic potential of the Chinese people, and not to some great wisdom on the part of China's authoritarian rulers. Sadly, because of the size of the Chinese market, Western governments tend to be far more interested in seeking contracts than in generating pressure on Chinese leaders to stop repressing their people.

I believe this setback is temporary. Today we are witnessing the incredible bravery of an increasingly outspoken civil society inside China. Xi Jinping is doing everything he can to arrest and silence these critics, but it's a losing battle. The old days when the Chinese government could challenge human rights as a "Western" notion are long gone. The fight for human rights in China is being fought inside the country now. We do our best to support our brave Chinese civil society colleagues who are currently operating under extraordinary pressure.

Or to name another challenge, despite our numerous reports documenting massive human rights violations in Syria, we have been unable to generate the kind of pressure that could end the abuse. Yet even in such a desperate situation, I'm convinced that our work has made a considerable difference, for example, by curbing the use of chemical weapons and forcing humanitarian access to people in urgent need. But I cannot help but feel a sense of defeat when close to 250,000 people have lost their lives in the last five years in Syria.

Religion and Philosophy

Which religions are good, which promote peace?
Any religion can be interpreted in positive or negative ways. For example, many people view Buddhism as the ultimate "peaceful" religion, but it has been used by extremist monks in Burma (or Myanmar) to whip up anti-Muslim sentiment. So the issue isn't whether any particular religion is good or bad, but how people use religion to further their goals, whether good or bad.

Most of the victims of terrorist attacks are Muslims, and most of the attackers too. Are you sometimes worried about Islam?
Again, the issue isn't Islam itself but how it is interpreted. Today, there are groups such as the Islamic State, or ISIS, that are promoting an extreme interpretation of Islam to justify atrocities and ruthless rule. However, if we think about who in the modern era introduced suicide bombing as a regular tool, it was the Tamil Tigers of Sri Lanka, not

Muslims. And Christianity is not immune to atrocities either: Today in the Central African Republic, the main source of atrocities has been the largely Christian anti-balakas, which attack Muslims. There are examples like this from every religion.

With which religious creeds and beliefs have you had the best experience?
I can point to human rights heroes and villains from every religious background. No religion has a monopoly on good or evil.

In what ways should religious organizations participate in fighting against violence and expulsions?
It is important for people of every religious persuasion to oppose voices of hatred or intolerance within their religion. Regardless of your religion, it is important to challenge those who claim that it requires committing atrocities.

In 1993, nearly a quarter of a century ago, Samuel Huntington published his controversial article *The Clash of Civilizations*. Is there now a danger of a "clash of religions," with religious beliefs playing an increasing role in the Middle East?
There has been a recent rise in sectarianism in the Middle East, especially between Sunni and Shia Muslims. Part of that reflects competition between Iran and Saudi Arabia, but much of it is built on fear. Once people are attacked because of their religious sect, there is a tendency to rally around one's kind in defense. But in multi-sectarian countries like Iraq and Syria, separation by sect would require massive dislocation. Instead, we are better off pressing governments to create a genuine space in society and a genuine role in governance regardless of religious persuasion.
Human Rights Watch emphatically rejects the notion that a "clash of civilizations" is unavoidable. In our experience, clashes among religions and ethnicities are the responsibility of leaders who make conscious decisions to play on these divisions to further their own power.
The world is growing smaller, and the interaction among all the world's civilizations is destined to grow. The way to make sure that happens peacefully is to vigorously insist on equal human rights standards for all.

Human rights are supposed to be universal, but are they really?
Abusive governments trying to avoid criticism of their repression
like to claim that human rights are not universal, but rather a Western
imposition. But that argument of convenience doesn't bear up to the
facts. First, as a formal matter, virtually every government of the world has
ratified the core human rights treaties, meaning they recognize these
norms as universally applicable. More to the point, I have traveled widely
and have yet to find people who want to be tortured, arbitrarily im-
prisoned, discriminated against, censored, or deprived of access to
food, housing or health care. The universality of human rights reflects
fundamentally the common needs and aspirations of human beings
around the world.

The only areas where there continues to be real debate about universality
involve rights concerning gender equality, religious freedom, and sexual
conduct. Some governments want women to remain subordinate, gays to
stay in the closet, and religious proselytizing and conversion to be
prohibited. But it's important to remember that the human rights move-
ment isn't forcing women to enter the public square, gays to live openly,
or people to change their religious beliefs. Rather, the human rights
movement is concerned about what happens when people *want* to con-
duct themselves in this way but their governments prohibit them. In
that case, the imposition isn't from the West but rather from local author-
ities who deny their people this freedom. The human rights movement
simply defends the rights of these people to lead the lives that they should
have the freedom to lead.

**Religions are specific, but human rights are universal. This means
that the foundation of human rights must be extrinsic to the religions.
How can this inherent contradiction between human rights and
religions be resolved?**
There is not necessarily a contradiction here. One can find the source of
human rights in many religious traditions, all premised on the inherent
dignity of each human being. People from many of the world's religions
participated in drafting the Universal Declaration of Human Rights in
1948. It doesn't matter which ethical or religious tradition you begin with,
there are certain rights and freedoms that are the essence of what it
means to be a human being. These should be respected.

You have traveled all around the world. You have seen the most dangerous and most frightening places on this planet. What would you say—how does evil come into the world, because of human desires like greed and aspirations of power? Or is it rather conditions in the world that shape how people turn out and behave? In other words: What is evil?

I don't believe in conditions dictating human behavior. Different people respond very differently to the same conditions. There is no escaping the essential role of human agency. Many people aspire to greater wealth or power, but only some use repression or brutality to achieve it. Other governments violate rights in the name of national interest or security. Because the temptation to abuse power is always there, watchdogs like Human Rights Watch are needed to raise the cost of indulging it.

Personal Matters

Where do you get your energy for your work?

When you're pursuing a passion, energy is never a problem. I feel extraordinarily fortunate to have been able to devote my career to a cause I believe in, for an organization that regularly makes an enormous difference, with a group of colleagues who are smart, dedicated, and effective. I don't find my "work" a burden; it's what I want to be doing. It motivates me intellectually and personally, leaving me feeling both challenged and fulfilled.

You have been HRW Executive Director since 1993. After more than 20 years, haven't you heard enough of terror, persecution, torture, and expulsions? You are now 60 years old. How long do you intend to continue?

Of course I wish there were no more horror stories to be told, but that's not the world we live in. So, yes, my day is made up of reading and hearing about terrible things done to people. I survive the onslaught by focusing less on the horrors themselves than on what we can do about them. There's a purpose to recording and publicizing those horrors,

because by doing so we can build pressure for them to stop. That gives me plenty of reason to keep going.

As for how long I should stay at this job, that's really a question about what's best for the organization. I have learned a lot in my time as executive director, so I think I'm far more effective today than I was when I started. There is value in experience, which, frankly, is why we make such an effort to retain valuable staff for the long term. But it's also important not to do something today just because we did it that way yesterday. I try to remain open to new ideas, but I recognize that I do represent a certain approach and set of strategies for the defense of human rights. At some point, an alternative approach may make more sense. Ultimately, the organization (and I) will have to decide when the advantages of continuity are outweighed by the advantages of change. At that point, I'll step down, grateful for the privilege that I have had of heading such a remarkable organization and working with such a dedicated and effective group of people.

You have a doctorate in law. How did you become an advocate for human rights?

Part of my reason for attending law school was to do human rights work, but my career didn't begin very auspiciously. At Yale Law School, each year I signed up for the one human rights course then on offer, and each year it was cancelled, so I ended up graduating with no training whatsoever in the field I wanted to pursue. To make matters worse, when I graduated there were no jobs. Human Rights Watch had all of two employees. Amnesty was bigger but still tiny. So I settled for volunteering. For six years, I worked during the day as a lawyer—mainly as a federal prosecutor in New York—but I spent many nights and weekends volunteering, mostly addressing human rights in Poland after the declaration of martial law in December 1981. Human Rights Watch knew me because of that volunteer work, so when a job opened up, they asked me if I'd be interested in applying. It didn't take me long to say yes.

Your father is said to have told you a lot about your grandfather's family while he was cutting your and your brothers' hair. What was this like for you? And what was your father telling you? Your

grandfather on your father's side had a butcher's shop in Frankfurt. Is there a connection between his story and your commitment?

You might say that my first experience with human rights abuse was through the stories that my father told to keep me and my brothers entertained as he cut our hair. At first the stories were funny, about the mischievous and fast horse that my grandfather used to transport meat for his butcher's shop. But as we grew older, the stories became more serious, as my father described what it was like to be a young boy growing up in Frankfurt under the Nazis—how he was forced to attend a Jewish school, how he feared severe repercussions for some minor infraction involving his bicycle, how my grandfather cleverly disposed of his World War I rifle to avoid giving the police an excuse to arrest him, how gradually, and with great difficulty, my family fled Germany in July 1938 and found a place of refuge in New York. These stories opened my eyes at an early age to the evils that governments could commit, and helped to build my determination to address them.

Are there any politicians who have inspired you to work for human rights?

Jimmy Carter played an important inspirational role for me at an early age. He was president when I was in law school, and he was the first to introduce human rights as an element of US foreign policy. Because of my upbringing, I was already inclined to understand the importance of rights. If I had been a bit older, I might have become involved in the major civil rights battles in the United States of the 1960s and 1970s. But by the time I graduated from law school in 1980, Carter had opened new rights terrain. I was already interested in the international domain, and Carter helped demonstrate for me how much rights work could be done there.

Have you spoken to your children about the details of your work?

I have always spoken with them about my work. The trick was how to do it when they were little. I used to tell my girls that there are a lot of mean presidents in the world, and my job was to make them be nice. For many years, that sufficed as an explanation. But they took in far more

than I realized. I recall once when one of my daughters—both of whom are now grown—was a little girl. She suddenly started talking about Bosnia—about the Muslims, and Croats and Serbs. I looked at her incredulously. How did she know about all that? She explained she had been listening to me talk on the phone.

I am now remarried and have an 8-year-old stepson. He is getting an education at a young age because my wife, a pediatrician and public-health professional, has been deeply involved in public health matters in Syria. In his short life, he has already taken five trips to the Syrian border. Inevitably he is learning first-hand about the consequences of an ugly war.

Is it possible to teach empathy to children and young people?
Of course it is. The best way to teach is by example. If we consistently show empathy toward others, our children will learn to do the same.

Interview: Ronald Grätz and Hans-Joachim Neubauer

"Lack of education is darkness"

An interview with Zama Coursen-Neff, Human Rights Watch

Human Rights Watch has assigned the ifa award to the Global Coalition to Protect Education from Attack. What is your task in the Coalition?
I co-chair the Global Coalition to Protect Education from Attack and I direct the Children's Rights Division of Human Rights Watch.

Before that you worked as a clerk for a judge in the US.
I have a US legal education and when I finished law school I spent a year clerking for a federal judge and then was lucky enough to get a fellowship from Human Rights Watch. I spent a year working on the rights of Burmese refugees in Malaysia, drawing on my previous experience of working on the rights of immigrants in the US. At the end of that year, in 2000, I was hired to work in the Children's Rights Division.

What did you start as?
I started as a researcher, working on discrimination in education, on bonded child labor in the silk industry in India. By 2002 I got involved in our work in Afghanistan.

What did you concentrate on?
In Afghanistan, we were looking at a whole range of abuses. In 2003 we started hearing from parents that a bomb had been left under a teacher's chair or a school was set on fire. So parents who had sent their kids to school had been taking them out again because of attacks. That was quite shocking.

How did you react?
With that in my mind I went back to Kabul trying to find out what was being done about these attacks. We discovered that these stories were not the kind that many people wanted to hear. Politically, the story was

that children, especially girls, were returning to school. Some local staff were afraid to report what was happening. There were serious concerns it might affect much-needed education funding. We collected and published a list of more than 30 attacks on schools. It stuck with me. We began to collect more information without knowing at that time that the attacks would increase tremendously. I'll never forget visiting a mud-brick school where children had found an explosive device before the start of class. Fortunately it didn't go off, but the building was empty and silent. On that same trip I interviewed a local education official who pulled threat letters out of his pockets to show me, warning him not to work to improve education. In 2006 we were able to report on more than 200 attacks over an 18-month period, and no one could deny any longer that there were intentional attacks on schools. That's how I got into this area of research.

Were those attacks restricted to a certain region or area?

We started to look at that problem more generally, among other places, in India. So we began to realize that this wasn't only a problem in Afghanistan, that this was probably something that was happening in conflicts around the world. It was in India that we first documented one factor in attacks—the use of schools for military purposes. In that conflict, our researcher found that Maoist rebels were targeting and blowing up schools, and also that police and paramilitary police fighting the Maoists were occupying schools, sometimes for a few days and sometimes for months or even years. In some cases they displaced the students entirely; in others the children struggled to go to school alongside armed men. We realized that something was happening around the world that we were missing in our research. We did more research in Thailand, Pakistan, Somalia, the Philippines, and elsewhere. According to the GCPEA, some 30 countries since 2010 have experienced a pattern of intentional attacks on schools, teachers, and students or the practice of using schools for military purposes.

How do the occupying forces act in schools?

In some cases they come in and kick all the students out. The kids try to go to another school further away or simply drop out. In other cases

we found soldiers moving into just parts of the school—a few class-rooms, the playground—while children continue to study in the remaining space. When children tried to continue to go to school, it created a terrible environment for learning and teaching. When soldiers moved in, many parents pulled their kids out of school, especially the girls. In some cases, children described soldiers drinking alcohol or bathing around them. A girl in Yemen told us soldiers brought a suspect into her schoolyard and beat him and tortured him with electricity. Boys may be especially vulnerable to recruitment, girls to sexual harassment and violence. We documented cases where soldiers hid weapons and ammunition in schools. Moreover, the military use of schools can even make them targets of attack. Students and teachers have been injured and killed simply for being caught in the crossfire.

Do all parents pull their kids out of school? It's an understandable reaction, given the enormous problems the children are facing.

Because of the risks posed by having troops in schools, some parents do pull their children out. In our research we have found that girls are often pulled out first—my colleague visited a school in India, for example, where the presence of just a few armed men was preventing some 200 girls from taking advantage of special scholarships to get girls who had dropped out to work or to get married back into school.

But some children and parents consider education so important that they will literally risk their lives to go to school. I'll never forget interviewing children who bravely continued to try to go to school in the midst of fighting in Mogadishu, for example. Others make a very rational choice that it is not worth the risk. I think many of us with children might make the same choice. This phenomenon came out, so by 2010 it was becoming clear that the problem of attacks on schools, teachers and students was very widespread and that the issue of the military use of schools was both under-appreciated and rarely restricted in most countries' national laws. By then we were asking, what can be done?

How did the Global Coalition to Protect Education from Attack come together?

By 2010, the issue of attacks on schools was coming onto the international agenda as a global phenomenon. While we were pursuing our own research, experts working in the area of education and emergencies were experiencing the problem on a first-hand basis. UNESCO published two important studies pulling together global research. And UN and NGO experts working for the protection of children and armed conflict at the UN Security Council were pushing for the Security Council to take stronger action. But it really required the convergence of experts and activists across these fields—human rights, education, and child protection—for us to really begin to understand the problem and what could be done. In 2010, following the publication of UNESCO's report, the people who ended up founding the coalition gathered in HRW's offices—during a blizzard, in fact—and said this is an area where we need to work together to advocate the protection of education in war zones.

The coalition includes both UN agencies and nongovernmental organizations, and it's quite unique. I do not know about any other example of this kind. As individual organizations, we have very different ways of working, different levels of risk in the field, and different relationships with governments. But on this particular area of protecting education from attack, we were all committed to doing something about it.

How do you rate the NGO-UN collaboration in this case?
Has it been of great use? Or is it just a means of showing good will?
None of us would invest the time and energy that we have just for show — there's too much worthwhile work to do for that! But a great deal has happened in this relatively short period of time. I think we are in the middle of changes that could never have happened had we not worked together. It's nothing that Human Rights Watch could have done alone, neither could any other Coalition partner—UNESCO, UNICEF, UNHCR, Save the Children, PIEC, CARA, and IIE. None of us could have done this work alone. But we have been able to do a lot together. I believe it's mostly due to my individual fellow steering-committee members —it's a smart and committed group of people who have been willing to work in a coalition that's new for all of us.

What is your actual work like? What do you personally do in the Coalition?

I co-chair the Coalition with a wonderful colleague from Save the Children, Veronique Aubert. The Coalition is governed by a steering committee of eight very active agencies and supported by a small secretariat, directed by Diya Nijhowne. At Human Rights Watch our Children's Rights team focuses on a range of human rights for children, including the worst forms of child labor, children in detention, migrant children, and the right to education. Several of us are dedicated to this topic, whether it's advocating at the UN or conducting research in the field—we have new reports this year on attacks on education in Ukraine and Nigeria, for example.

That doesn't seem to be a job for just one person.

Right, this really is not a one-person or one-agency show. In the Coalition we have really good people, who from the beginning were thinking about how to activate their own agencies to work on this topic and to do things they had never done before.

What does your everyday work consist of?

Well, it's a mix of advocacy, writing, editing, planning, and managing a team of wonderfully dedicated experts. And as much travel as I can manage. The Coalition is spread all over the world, and my own staff are spread from Los Angeles to Beirut. Both GCPEA and HRW are global organizations.

Since starting your Human Rights Watch job in 1999 you have dealt with thousands of cases. How is it that you can still smile?

When you actually see something change, you do smile. The people we meet have often faced unimaginable losses—their teachers or their students maimed and killed, their own children denied the fundamental right to learn. But we also meet people of unimaginable bravery. With our small team of child rights activists, I get good news of things that are working almost every week.

Can you give an example of good news?
As of May 2016, 53 countries have joined the Safe Schools Declaration, a political commitment to protect education from attacks launched in Norway a year ago. The Declaration includes an endorsement and commitment to use the Guidelines for Protecting Schools and Universities from Military Use. Given that this issue really wasn't on the global agenda before 2010, six years is a really short time, I think, to have this kind of action. There's a lot more to be done, but the trajectory is promising!

In 2011 the UN Security Council strengthened its response to attacks on education.
In 2011, the UN Security Council made attacks, be they on teachers, schools, hospitals or medical personnel, something that specifically can get parties added to the UN list of shame for grave violations against children in armed conflict. Besides getting the notoriety, parties on the list can face very serious penalties from the UNSC, including sanctions and being referred to the International Criminal Court. The Security Council also asked the Secretary General to monitor military use of schools. Since then the amount of data on this issue coming to the Security Council has increased dramatically. The UN Special Representative for Children and Armed Conflict has also been a passionate advocate on this topic, calling on UN member states to join the Safe Schools Declaration.

Do you think that any forces will obey rules restricting the military use of schools?
I think that most soldiers are trained to follow rules. So having clear rules about when they can and cannot use schools is critical. They also need to be trained on them, and held accountable for following those rules, too. So we began a process for establishing practical rules that troops could use in the field.

In December 2014 the "Guidelines for Protecting Schools and Universities from Military Use during Armed Conflict" were finalized.
Yes. And in May Slovenia became the 53rd state to sign the Guidelines. This is really a good number. But it is not enough.

When I checked that list prior to our conversation I saw that
there were some states missing. The US, China, France, the UK,
Russia—and Germany, too.
Germany was a particular disappointment.

Why especially Germany?
Because Germany led the way on the Security Council to strengthen
the response to attacks on schools and teachers. Last year the Security
Council asked countries "to take concrete measures to deter such
use of schools by armed forces and armed groups." The Guidelines
provide such concrete measures. We feel that it is becoming increasingly
untenable for the big, well-resourced militaries to defend the practice
of schools being used for military purposes. Particularly when a growing
number of states affected by conflict have signed the Safe Schools
Declaration. We hope that at this point we could have some kind of a
re-consideration, keeping in mind the words of the UN Secretary
General: "The use of schools for military purposes puts children at risk
of attack and hampers children's right to education… Such use of
schools not only results in reduced enrolment and high drop-out rates,
especially among girls, but also may lead to schools being consid-
ered legitimate targets for attack."

**Do rules, guidelines, or regulations have any effect? Can words
change the world?**
They do when they're implemented. Just to note, even before the
Guidelines took effect, the UN Department of Peacekeeping Operations
changed its infantry manual to prohibit peacekeeping forces from
using schools for military purposes. We are increasingly seeing these
restrictions being implemented, and the sky doesn't fall.

**Do you think that there is growing pressure on these countries, due
to the fact that more and more countries are signing the Guidelines?**
I hope so. I hope that there will be encouragement from other govern-
ments. I think that if for example France looks at Côte d'Ivoire and
other French-speaking countries, which say we don't want our schools
being used in armed conflicts, it's very hard for a country like France
to defend its position.

Do you see that the Guidelines are having any impact on war lords, on unofficial armed forces or irregular troops? For instance, Boko Haram and comparable groups are specialized in attacking children, schools, and educational premises.

The various non-state armed groups and the ability to influence them differ greatly. Some care about their reputation, about media exposure on school attacks that highlights the damage they're inflicting on children and education. I think that the condemnation of these attacks by the UN helps to stigmatize any attacks on schools. And there are groups which are interested in getting off the UN list of shame and want legitimacy. Eighteen armed non-state actors have signed a Deed of Commitment for the Protection of Children from the Effects of Armed Conflict, developed by the organization Geneva Call, which includes a promise to avoid using schools for military purposes. It's also worth noting that the International Criminal Court can prosecute intentional attacks on educational institutions that are not being used for military purposes.

Besides the background work on the political stage, what can be done so as to improve the actual situation of schools, teachers, and students?

At the field level, teachers, school administrators, and, often, aid agencies are doing many things, like improving the physical protection of schools with boundary walls, organizing parent escorts, experimenting with early-warning mechanisms, and even in some cases negotiating with groups to make schools off limits. The Coalition has published a series of papers documenting what's being attempted in various places and has shared that information widely among practitioners. There's also much more to be learned about attacks on higher education— the terrible attack on Garissa University last year is just one example of why this aspect of the problem needs more attention.

So you think that there is a measurable impact of rules and declarations on reality?

There is no magic in it; these things take time. But think about the fight to stop the use of child soldiers. Since 2000, 162 countries have ratified

the international convention raising the age of recruitment to 18,
and the number of child soldiers has been reduced drastically. Twenty-
five years ago far fewer people than today thought that it was such
a bad thing for a 16- or 17-year-old to fight as a soldier for an armed
group. Today most people agree that it is wrong.

In which areas, which countries have you been working?
My own field research was mostly in Somalia and Afghanistan. I can give
you some visual snapshots I have in mind. We did research on attacks
on schools in Somalia from a refugee camp, where we interviewed
all these children who had been captured by Al-Shabaab and managed
to escape. And many were so hungry for education that they were
willing to risk their lives in Somalia to get an education that was probably
of terrible quality.

Can you think of a specific story that touched you more than others?
In 2006 and 2007, during my sabbatical, I worked in Sri Lanka with
a Norwegian humanitarian agency. During that time the government was
bombing the area being held by the Tamil Tigers. As they wanted
people around them, the Tamil Tigers didn't allow the civilians to leave.
So people were fleeing through snake-infected lagoons, or just walking
through the jungle, trying to get out of those places being bombed.
There were around 120,000 displaced people in camps throughout Batti-
caloa town. The government was transporting them to schools, and we
were working with the UN trying to identify basic needs—sleeping mats,
latrines, potable water. One night, at a school, buses of people were
coming into the courtyard and we were directing them into tents, totally
simple tents, one tent for one family, then two families to a tent, and
the buses kept on coming. You see, some of the refugees had been going
through the jungle with no shoes, and they said: "Next week there will
be an exam at school for my child. I have to know how my child can take
these exams." Even in the midst of a conflict people had the desire
for education. The last thing you might expect people in such conditions
would do is to ask for education. But that's what they did.
I'll never forget interviewing children from Somalia who had literally
risked their lives to get to school in Mogadishu amidst fighting. One boy

described being abducted from school by the armed group Al-Shabaab when he was 12 years old and trained to fight. When he ran away from the training camp, Al-Shabaab fighters came to his house looking for him and shot his father. He escaped to Kenya, where I met him, and he yearned to return to school. "Lack of education is a lack of light," he told me. "It's darkness."

Or take Afghanistan. Would you send your 7-year-old daughter to walk five miles through the forest, across streams, no roads, to a school where an under-educated male teacher might not teach her to read? And perhaps would expose her to gossip that would threaten the family's status, and on top of that risk an armed attack on a school? But some people do. It's that hunger for education that drills into my mind that this is people's right—to have a safe, quality education.

Could universities or schools in Europe or the US do something to support the aims of the Coalition?
Yes, they can put their own governments under pressure to sign the Safe Schools Declaration. If we had a strong network of German schools and universities saying to the German government, "We want you to change your policy", that could be very effective.

Interview: Hans-Joachim Neubauer

"People are the basis of society"

An interview with George Soros

Imagine someone who has never seen you, never heard about you, knows nothing about you. Who would you tell them George Soros is?
I would say that I am unlike the majority of individuals who claim they are trying to make the world a better place. I'd ask them to learn about my interests and my foundations for themselves, as there are a lot of negative rumors in the public domain about me and my beliefs, which I suppose have naturally resulted from taking a stand on a number of different causes and creating a number of different detractors in the process.

In 2010 you gave Human Rights Watch, which is receiving this year's ifa Theodor Wanner Prize, 100 million US dollars. Why did you do this? Why such a large amount?
About 35 years ago I had an apprenticeship of sorts at Human Rights Watch, and used to attend their weekly meetings. Since then I have watched Human Rights Watch grow into a massive organization. I seriously doubt they will lose any zeal or commitment to their mission, and therefore they deserve my fiscal support for at least the next five years.

What do you expect in return from Human Rights Watch?
Nothing.

Nothing? The money is for whatever they think is best?
They have their own program and they set their own goals, which I fully support. The main objective of their expansion is to evolve from a primarily American organization into a global one. That's really the specific objective of this grant.

Do you try to influence how the money is used?
No. What Human Rights Watch does is their business. They provide me with annual progress reports in which they illustrate their goals and

how far along they are in accomplishing them. According to their last annual report, I would say they're ahead of schedule.

Why do you believe in organizations like Human Rights Watch and their aims?

People are the basis of society; as such, they have to participate in shaping society. This concept (the "Open Society") is the mandate of my foundations. Civil society is an important component of an open society, though it is not the only component. We also need governments that serve the interests of their people rather than their own interests.

So there are two sides of one coin, the government and the civil society…

Exactly.

…for the same projects. Are there any HRW projects that have particularly impressed you?

I've been impressed by their work as a whole. It's quite widespread—they focus on children's rights, women's rights, the rights of oppressed minorities, very much the same groups that my foundations are focused on helping.

Which areas of HRW work do you think are especially important?

Human Rights Watch works on a broad range of activities, all of which are equally important.

How do you see the relationship between HRW and state institutions? It seems that you do not trust states to adhere to human rights. Noting the increase of human rights violations worldwide and the rapid decline in values (IS, Boko Haram), isn't it fair to doubt that NGOs like Human Rights Watch can achieve very much? Is it not the power of the state and the military that is needed—like Jeb Bush is always speaking about?

No. I actually think civil society can make a big contribution on the soft side. I would also argue that hard power seldom accomplishes much. Sometimes you can appeal to the conscience of the oppressor. Even in serious instances of persecution like the Holocaust, a lot of people were saved by the people who were persecuting them but who were not

fully committed to their duty. So sometimes you can actually appeal to them. It's also important to note that soft power and hard power are interconnected. You cannot rule the world by military means alone. You have to have an impact on people who are violating human rights in order to stop them. That's actually what Human Rights Watch is doing, and they are doing it quite successfully.

We have recently published a book about human rights and culture, because human rights are not a global value. For example: Is the circumcision of girls a cultural right or violation of human rights? It's definitely a conflict related to human rights and culture. It's difficult, because the Chinese, for example, would define human rights completely differently to how we do.
The binding of the feet of Chinese women, for instance…

Yes, or the rings in certain regions of Africa.
Well, these issues are complicated. We have to try to convince certain people that their practices are harmful and get them to moderate them. In the case of female circumcision, it is clearly harmful and we have to stop it, if not with persuasion then with dictation. We have to outlaw it and make the practice and the practitioners liable. You can do it, but it's difficult.

How do you view the future of Human Rights Watch? Where should it concentrate its work?
The people at Human Rights Watch are faithful to their mission and adjust their focus accordingly. They pursue the violations where they occur, they have increasing worldwide coverage and they adjust their program well. Sometimes they aren't involved in covering a particular violation of human rights, but you cannot address every injustice at once.

Two years ago you opened a European office in Barcelona. Why didn't you open your European office in Berlin?
We cover Berlin. We cover Berlin carefully because I believe the European Union has lost its way to a certain extent. Human Rights Watch and the Open Society Foundations have been working tirelessly to rectify that.

Interview: Ronald Grätz

Ed Kashi

Sugar Cane
Syrian Refugees
Photographs

Under Cane: A Workers' Epidemic

An introduction by Ed Kashi

In Nicaragua, the average lifespan of men who harvest sugarcane is 49 years. At the root of these early deaths is an epidemic known as chronic kidney disease of non-traditional causes (CKdnT). In the town of Chichigalpa, often called the "Island of Widows," one in three men, mostly cane workers, have end-stage renal failure from this fatal occupational disease. In Central America alone, over 20,000 sugarcane workers have died from CKdnT in the past ten years.

Beyond Nicaragua, the Central American country of El Salvador is also affected by this epidemic. According to the Center for Public Integrity, CKdnT is now killing more people in Nicaragua and El Salvador – the two countries with the highest mortality rates from the disease – than HIV/AIDS, diabetes, and leukemia combined.

Research on the subject of CKdnT indicates that repeated dehydration, severe heat, overwork and pesticides and other environmental toxins might play a huge part in the rising death toll among sugarcane workers. These clues need further investigation and increased media coverage to find solutions to this widespread, critical problem.

With one private sugar mill in El Salvador poised to make history by becoming the site of the first ever CKdnT workplace intervention in Central America, labor conditions have improved due to increased water access, shade and mandatory breaks. However, since this fatal disease is both a global public health crisis and a social injustice, more research and health solutions are essential to continue creating a positive impact on the lives of affected workers, their families, and local communities.

What first began as an assignment in early 2013 for La Isla Foundation has developed into a personal project and mission to raise awareness about a fatal, and likely preventable, disease affecting agricultural

workers around the world. Chronic kidney disease of unknown origin (CKDnT) is considered an epidemic and spreads among sugarcane workers who endure long hours in hot fields. It is likely the result of dehydration, heat, and fatigue and has sparked a blame game between governments and communities—a game that takes a very measurable toll on the workers and their families. Yet virtually everyone on Earth consumes sugar in some form, so we are all complicit in this story.

As I documented yet another wake and funeral for a cane worker too young to die (35), I looked into the tear-filled eyes of his 15-year-old daughter and then at all the young girls and women and thought about the impact on a community where most of the men get sick and die. People are still dying nearly every day. We are not aware of improved worker conditions, and instead of adequate water they are receiving sugar-infused liquid hydration packets, which are very detrimental.

During my recent visit to El Salvador, conditions at one private sugar mill were markedly better due to an investment which provided for increased water access, shade and mandatory breaks, but I am personally frustrated, perplexed, and distraught by what I have witnessed. Using the power of photography and video to generate education, support, and community awareness, I believe my passion and commitment to being a part of positive change, while continuing the drumbeat of awareness, has only grown as I watch yet another child left fatherless and another family confronting an illness that can be avoided. This workers' epidemic, which is also being found in other parts of Central America, India and Sri Lanka, is an absolute human rights issue, which must be addressed.

The health crisis has led to clashes between the police and workers in Chichigalpa. After a worker died in one such confrontation, the government has said it would mediate between the protesters and their employers. There has been some criticism of La Isla by local groups for not being representative of the larger community, while the company that controls the industry, Grupo Pellas, insists it has taken steps to ensure proper hydration and working conditions, among other points.

It is less about placing blame and more about raising awareness so we can create support for the people impacted by this epidemic and

energize people to find solutions. This is what human rights activism means to me as a documentarian. While it is important to work for big media so the message can reach the masses, one can have a major impact by reaching the right 1,000 people and have a more targeted impact with people who are actually in a position to make a difference. This work can also be used by schools, nongovernmental organizations and even the local community to educate and raise awareness. How do we use visual storytelling to not only tell the tough stories, but also to offer some light? That's why in my practice my goal now is to humanize and maintain the dignity of my subjects and open people's eyes so they will at least learn, and maybe also take action.

As a photojournalist you sometimes have to look deeply to find your story, or it takes some time to figure it out. In this case it was thrown at me: In the town we were in, there was a funeral every day. The evidence was plain to see. It was like a refugee camp, with run-down wooden houses and no running water. I thought of the similarity and then I thought 'Wait a second, these people live here, they work here, this is unacceptable, it's not supposed to be like a refugee camp.' The injustice is appalling.

Syria's Lost Generation

An introduction by Ed Kashi

I started traveling to Syria in 1991 as part of my first project with *National Geographic* magazine documenting the struggle of the Kurds. I've returned a number of times for different reportages, and since the Syrian Civil War tragically developed out of the hope of the Arab Spring in 2010, I've watched with disquiet and pain as this conflict became a proxy for the wars inside Syria's fragile ethnic mosaic. More than two

decades after I had documented Kurdish refugees streaming back from Iran and Turkey to their fractured homeland in Iraq, I returned to the same patch of land to witness the impact of Syria's unending Civil War in late 2013, to tell the story of Syria's Lost Generation.

As refugees stream across Syria's borders, we are seeing the loss of another middle-class Arab population and the destabilization of another Arab, Muslim country. The youth within this new group of refugees makes up more than half of those four million displaced souls. What will happen to Syria's next generation? I had been there often enough to know that the Syrians are calm and well-educated people, used to relative security and stability, albeit under the hand of an authoritarian regime that was now firmly entrenched in its fourth decade of rule. What happens when the whole fabric of a society is blown apart, frayed not only at its edges but threatened at its very heart?

I returned to northern Iraq and Jordan to tell the stories of some of these young people. I wanted to create an intimate look into the lives of those caught in the middle, left in limbo, robbed of their childhoods.
The plight of Syria's youngest in the midst of the Civil War is often overlooked, when not hidden outright. At least 10,000 of the nearly 200,000 estimated deaths since 2011 are thought to have been children—they died too soon, but at least were spared some of the hardships now plaguing more than one million young Syrian people living beyond their native borders: hunger; disease; little to no education; flashbacks or nightmares sparked by the sights and sounds of warfare; depression.

As the unimaginably brutal conflict ends its fourth year, we are witnessing one of the greatest human rights tragedies of this or any century. My work has attempted to highlight the emotional toll the war is taking on the youngest of those driven from their own country. In coordination with the International Medical Corps, I met with and filmed Syrian teenagers (and their families) profoundly rattled by the collapse of their old world and their new, unsettled life as refugees in northern Iraq and Jordan.

My first stop was in Jordan, where I filmed a group of four teens living with their 83-year-old grandmother in the eastern desert, next to a small

agricultural plot where tomatoes and zucchinis are grown. They were part of a small enclave of maybe ten families living in tents, surviving on the good graces of a local farmer but disconnected from all the aid and supplies of the giant Za'atri refugee camp, now the second largest in the world with nearly 200,000 people, and only one hour away.

This dislocated family of teens—Muna, 16, Sumaya, 15, Bilal, 14, and Lamia, 13—had first traveled to Daraa in the south and then over the border to Jordan. Their parents had made them leave their hometown of Hasakeh, Syria, to avoid rape of the girls and conscription of the boy into the military or the Free Syrian Army.

They left behind their parents and four other siblings, and I found them living in a tent. For me, this story was especially poignant. I have two teenage kids, including a 16-year-old daughter. My heart ached for the mutual loss this family was going through—the kids separated from their parents, unprotected and in limbo— and I also was in awe of their strength and adaptability. When 16-year-old Muna told us, "I wish I had not lived to see the things I saw…and my greatest fear is never seeing my parents again," everyone in the tent, including myself, my interpreter and the folks listening on the periphery, were in tears.

I also filmed people in the Domiz camp just outside of Dohuk in northern Iraq—the region where I had witnessed Kurdish refugees returning from Turkey and Iran in 1991. It was sobering to witness yet another refugee crisis 22 years later.

Here I met Jihan, 16, and her family, who had fled from Damascus over a year earlier. Beautiful, articulate, sensitive and deeply troubled from not only what she had witnessed, but by the realization that, "maybe I've lost my adolescence,"—her story powerfully articulates the plight of Syrian youth.

In one instance, while filming in Jihan's family's tent, her father made a cellphone call. I intuitively filmed close-ups of his face, and the reactions of the family. As the call progressed, I watched the faces of the kids transform from looks of concern to quiet tears. My interpreter told me later the father had just learned that a bomb had killed his neighbor's 17-year-old son.

Jihan has lived in the Domiz refugee camp for more than two years. The surrealism of her situation—like many exiled Syrians, Jihan's middle-class family now calls a cold, dark tent in a foreign land home—and the pain of leaving others behind has changed Jihan, perhaps irreparably.

Here you have a young woman who became an activist as a teenager back in Damascus and who was upset with her father for leaving. She felt she should have died a martyr there rather than leave everyone. Jihan is articulate, open to discussing her and her family's struggles and eager to use her story as a platform to draw attention to what she and others are going through. Still, her anguish is clear.

Everyone handles it differently. Some accept their displacement as fate; others, like Jihan, have real trouble accepting their status as refugees. Once in the field I immediately latched onto Jihan. With her testimony, she stitched together an intensely personal account of what has become a universal experience for young female refugees—a struggle that, among other challenges, includes caring for siblings and threats of sexual assault.

What will these kids grow up to be? We need to care about this if we want to stop the cycle, and if we want to have any impact on the cycle. You just have the sense that this is not going to end any time soon. Whenever that happens, it's the children who will watch the pieces of their homeland be put together again, and it's they and their own children who will have to live with however those pieces are arranged.

What I witnessed leaves no doubt in my mind that at least in northern Iraq, the expectation is that many of these folks will remain permanently and not return to Syria. The world, and specifically the Middle East, is witnessing the reformation of its artificially made borders nearly 100 years after they were created. And its youngest will pay the heaviest price.

Ed Kashi

Sugar Cane

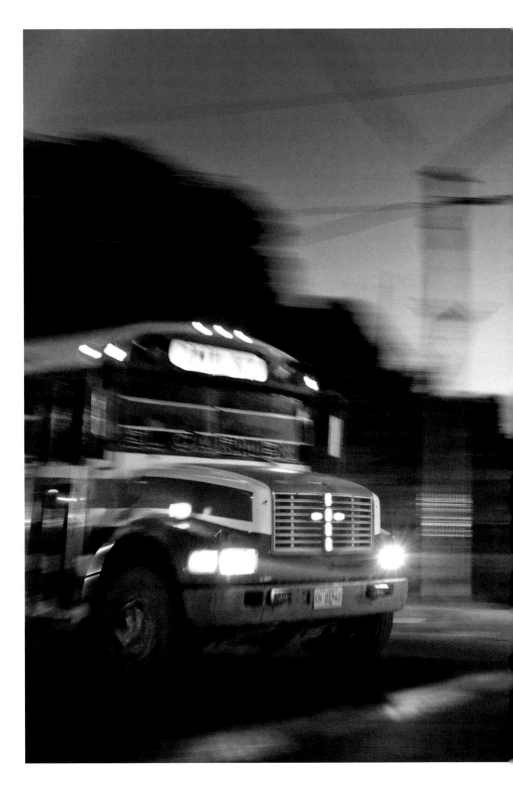

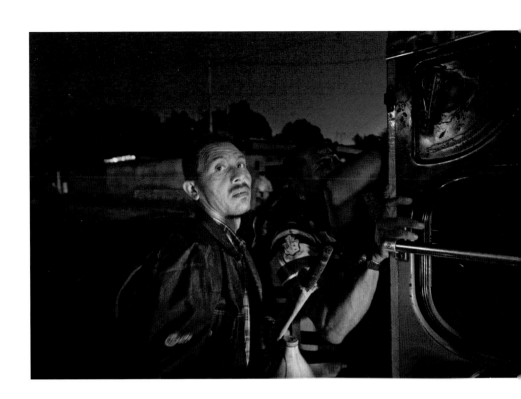

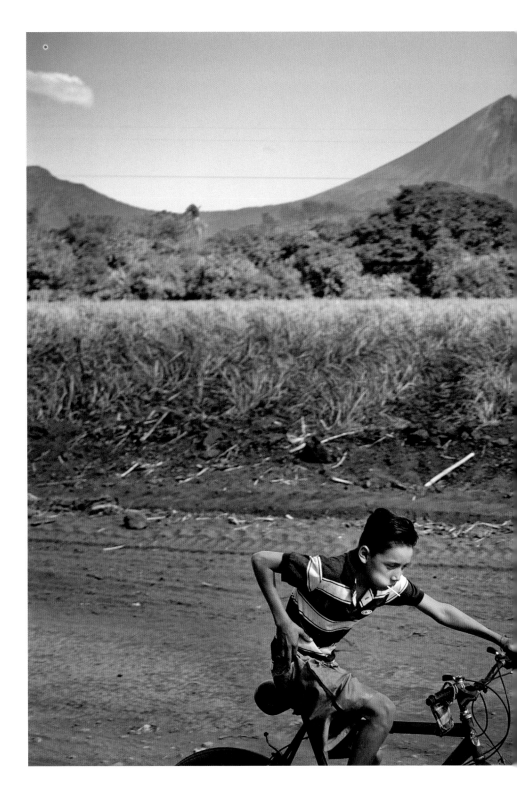

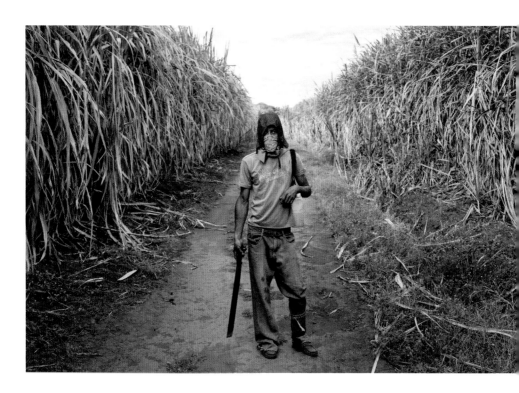

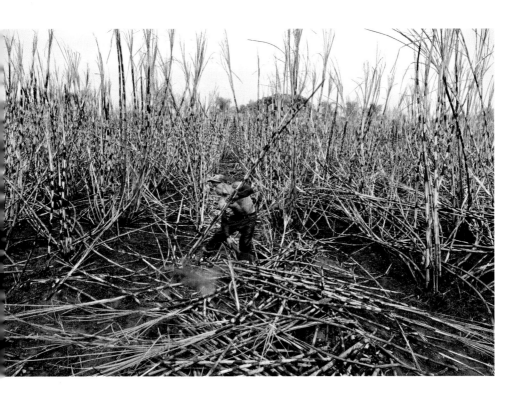

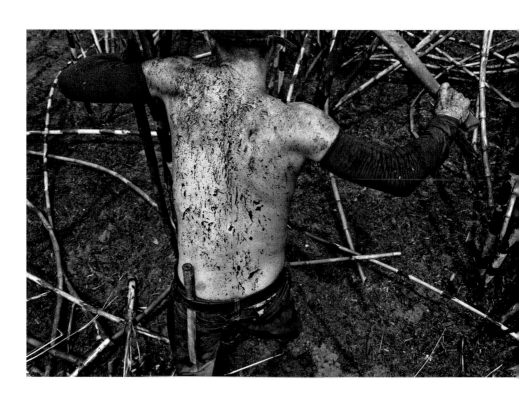

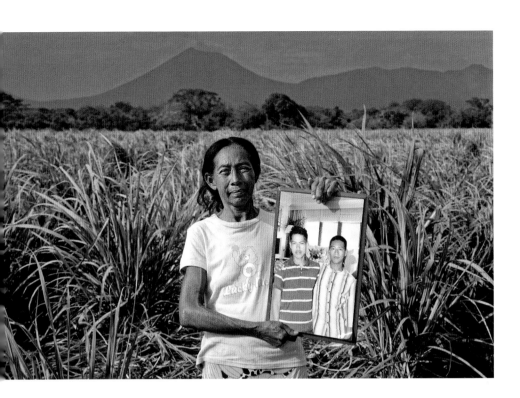

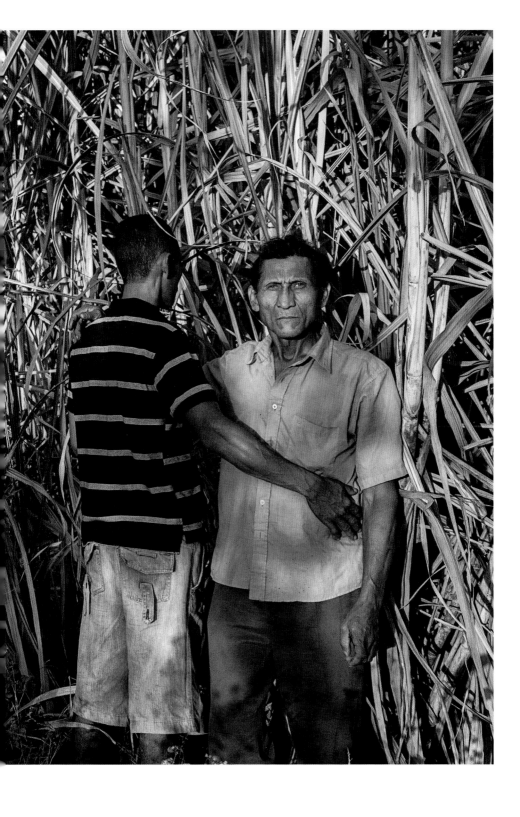

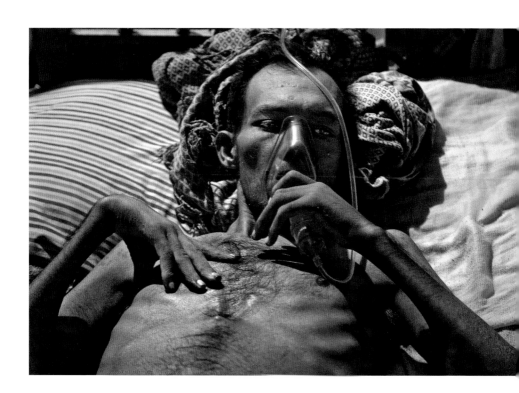

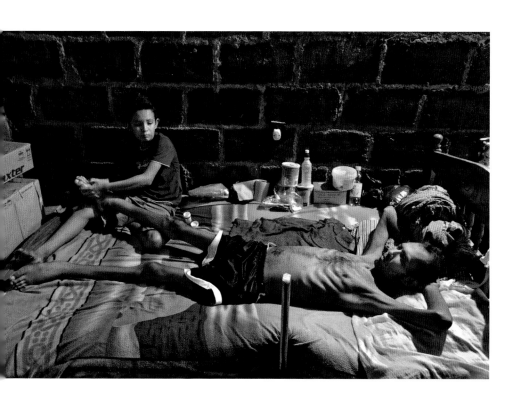

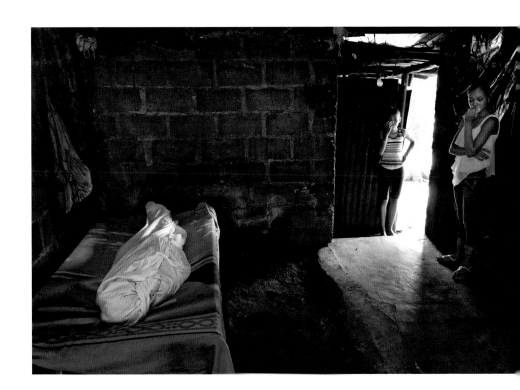

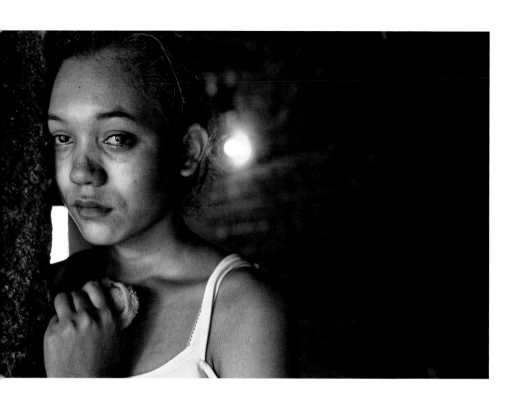

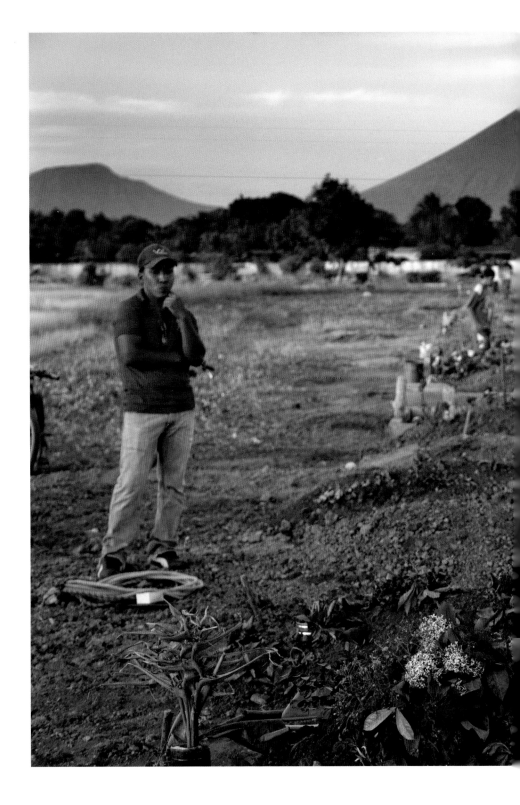

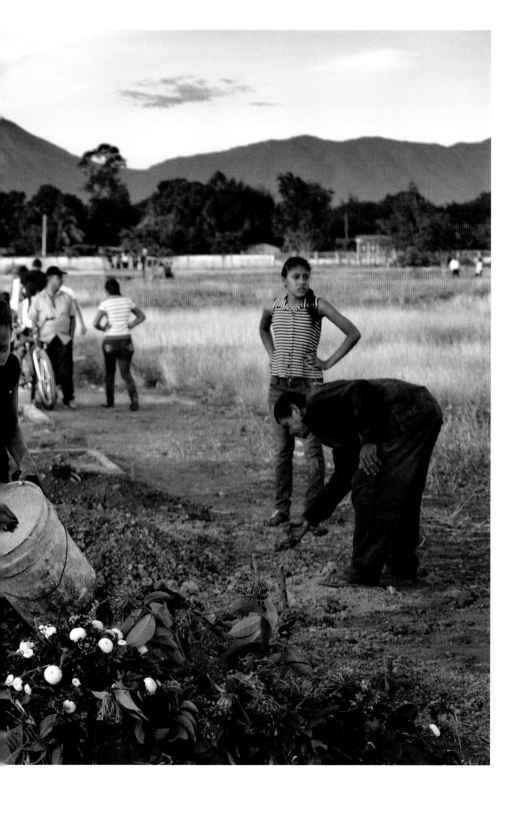

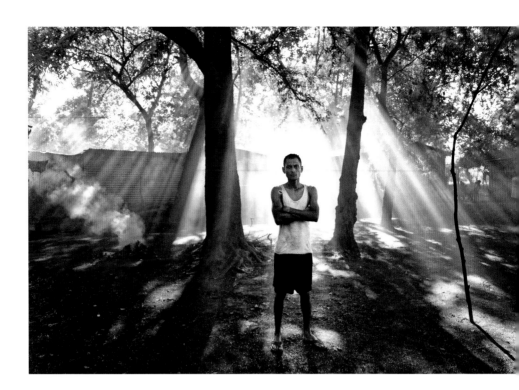

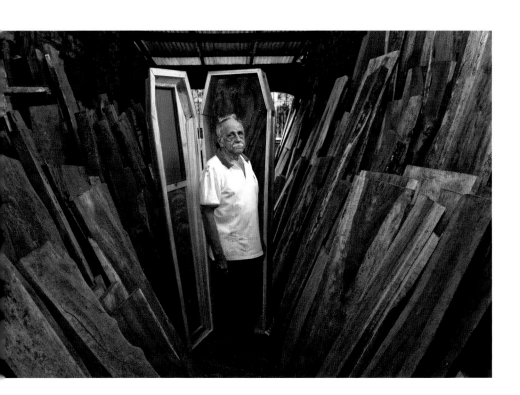

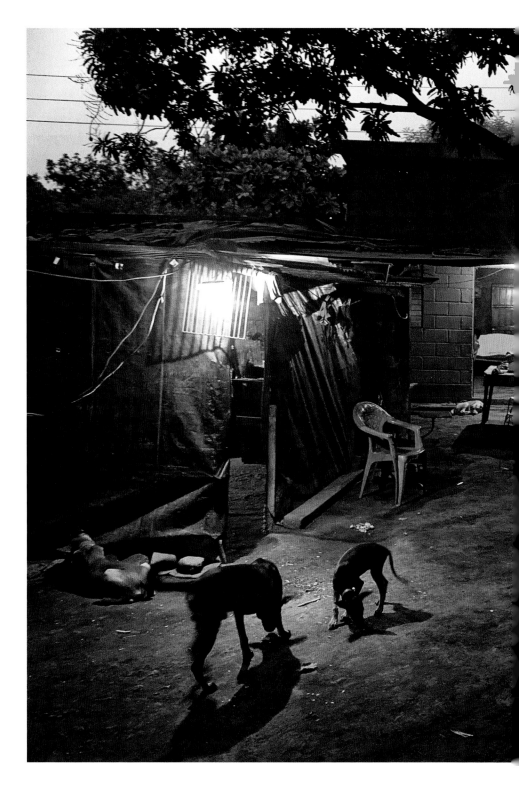

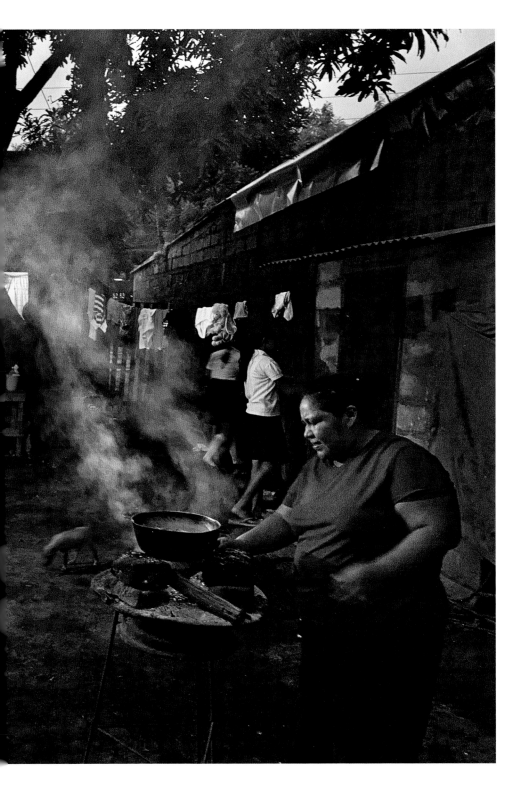

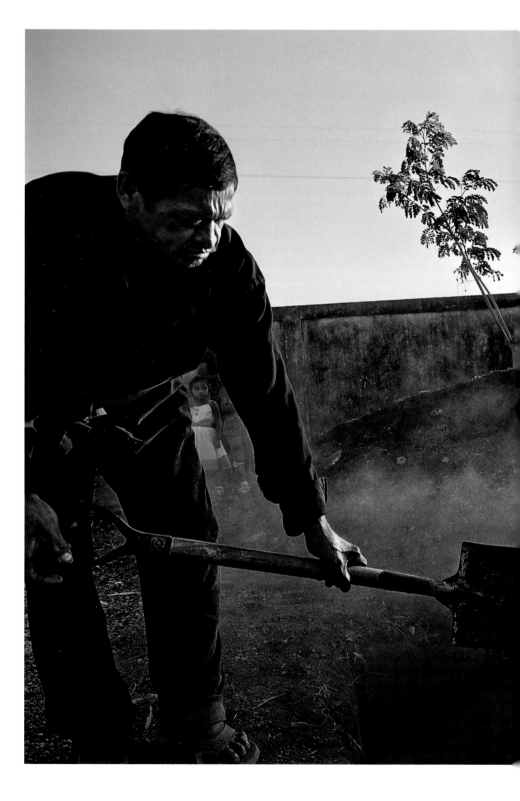

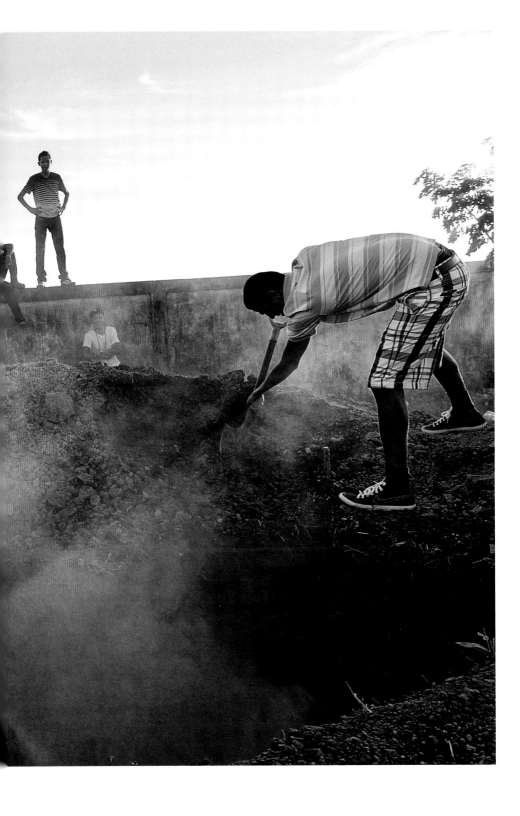

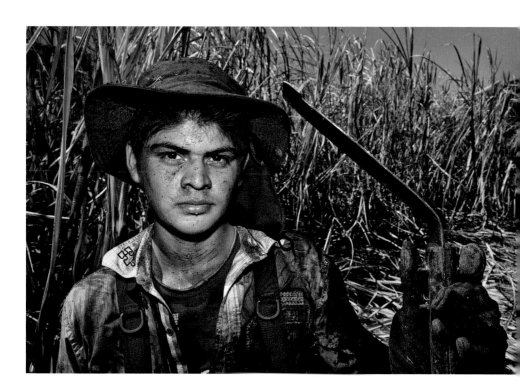

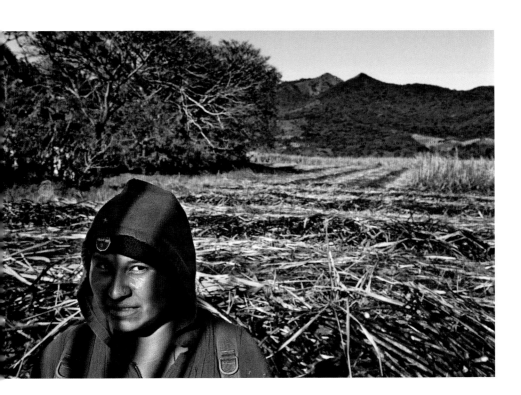

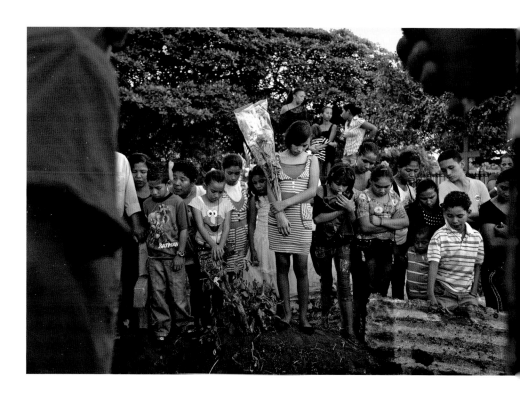

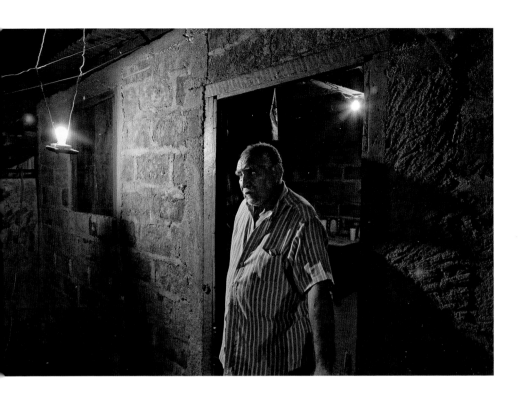

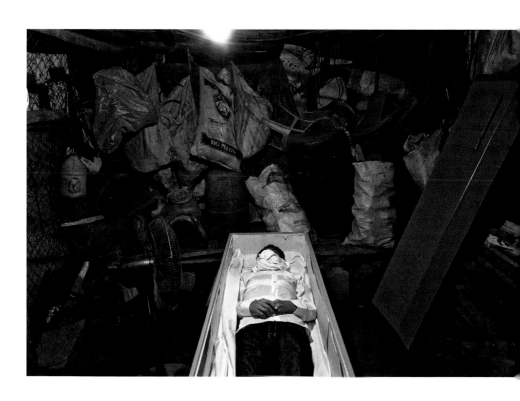

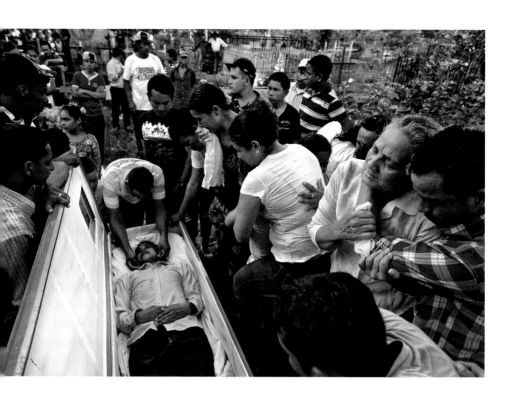

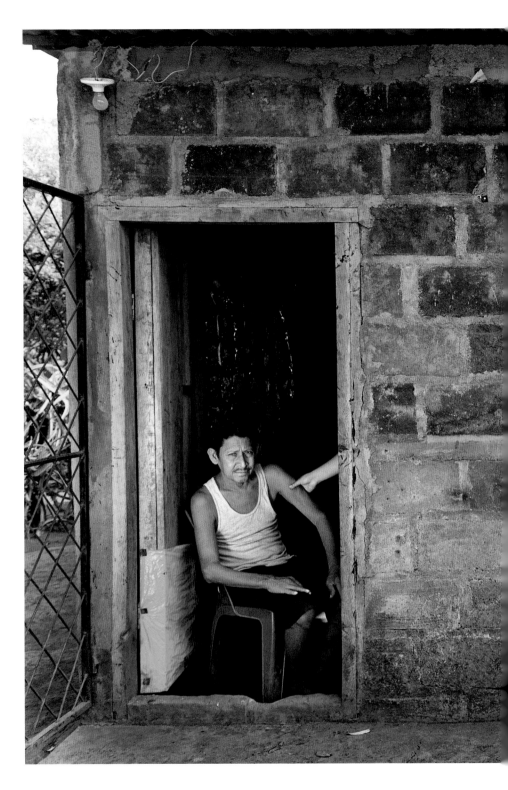

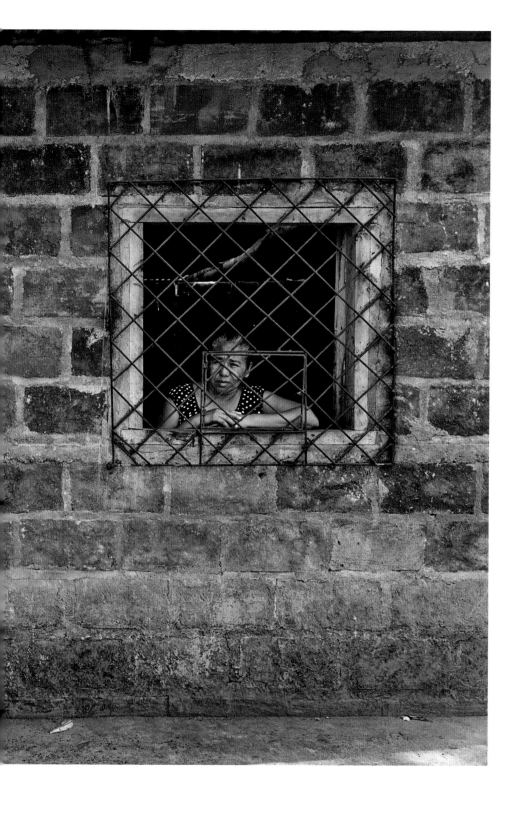

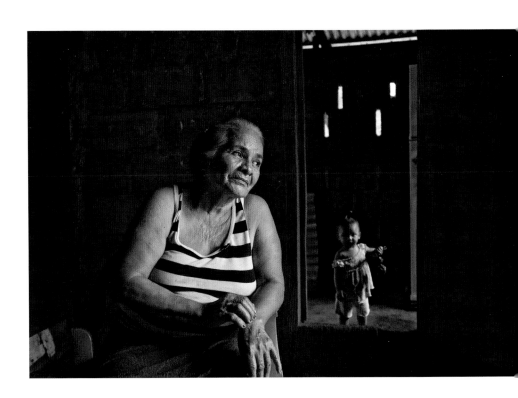

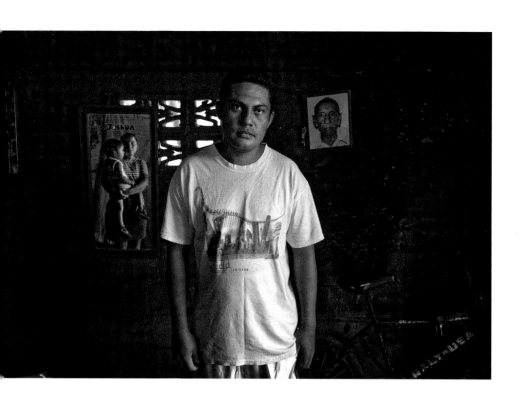

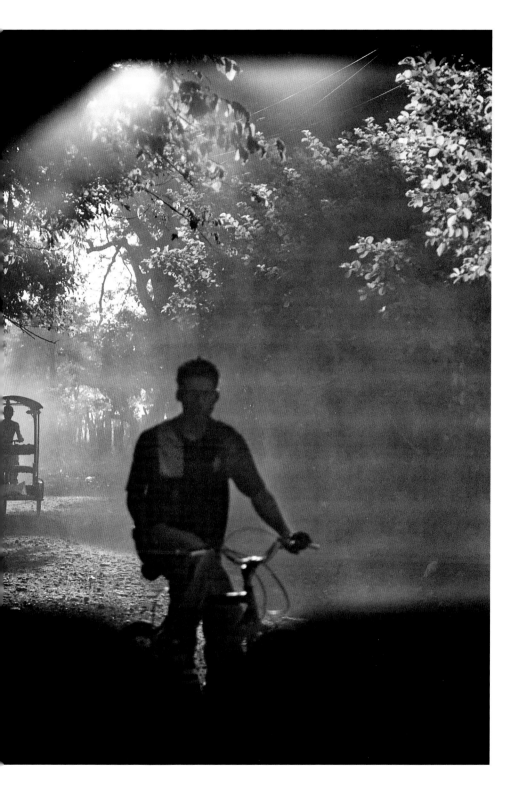

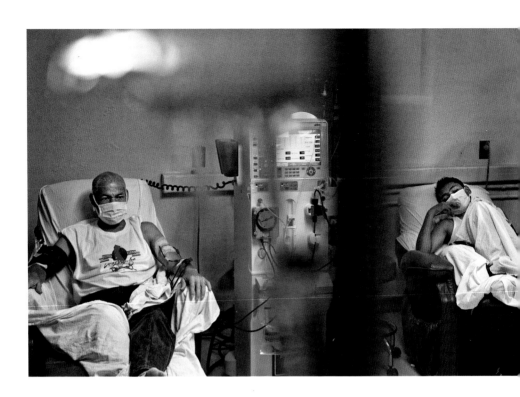

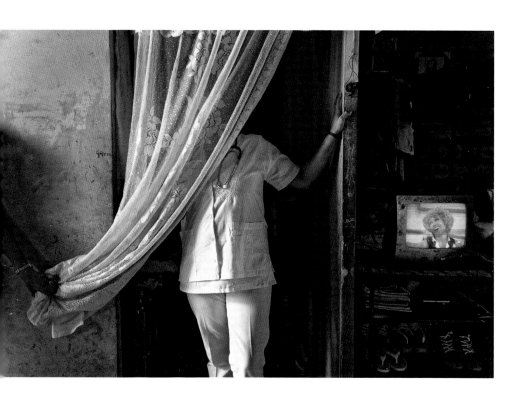

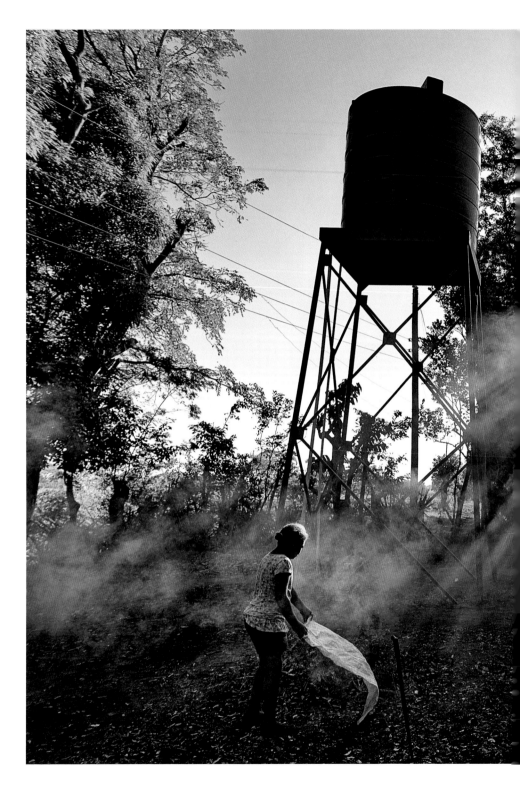

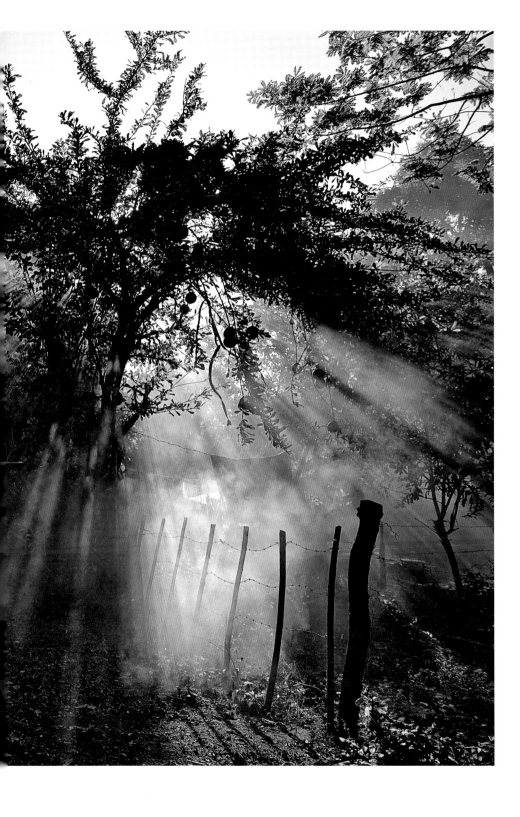

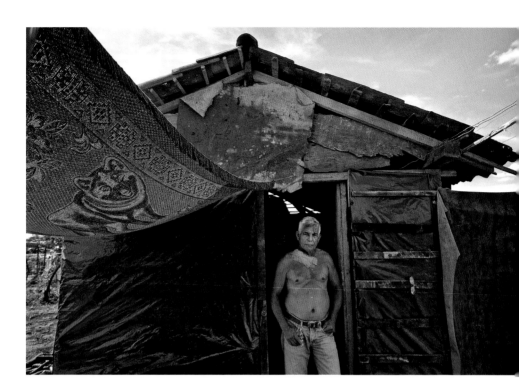

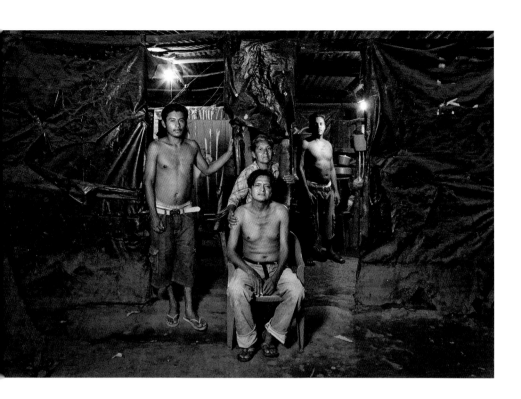

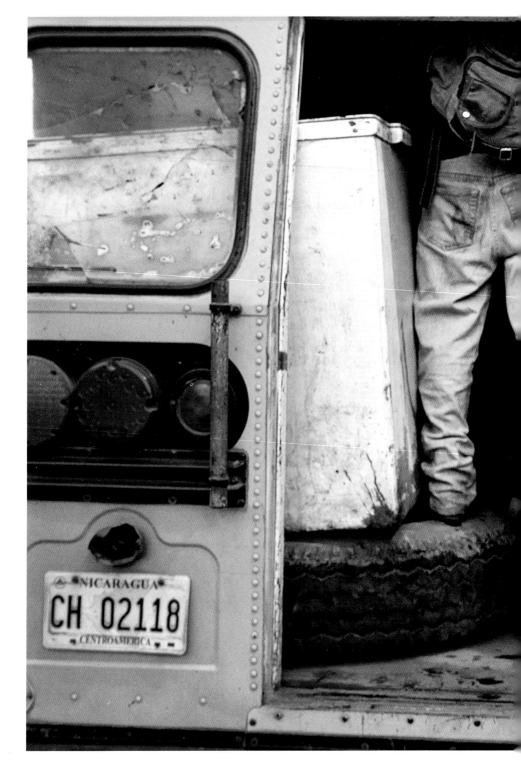

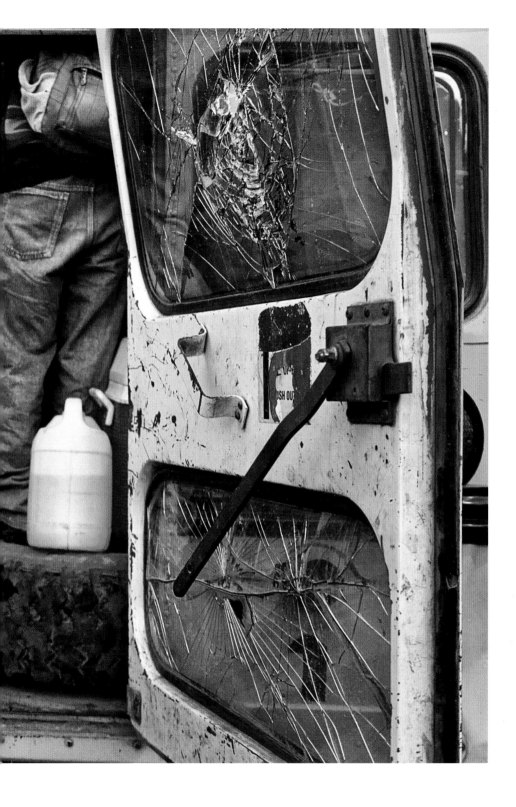

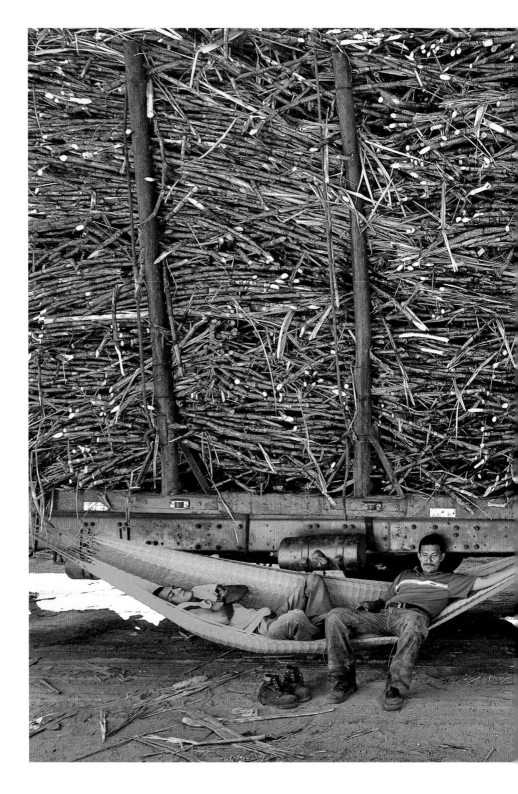

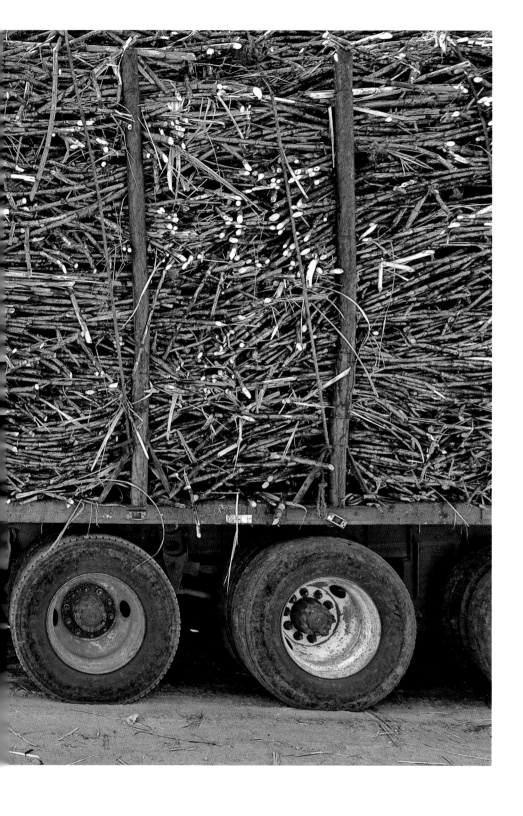

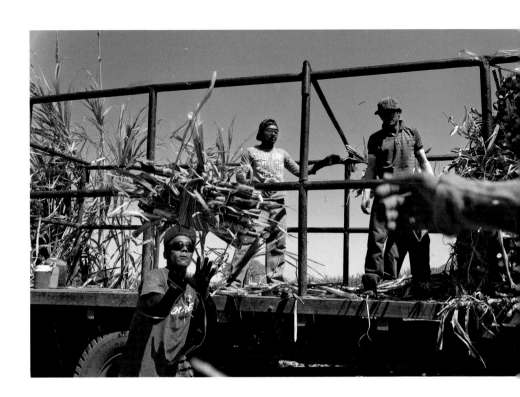

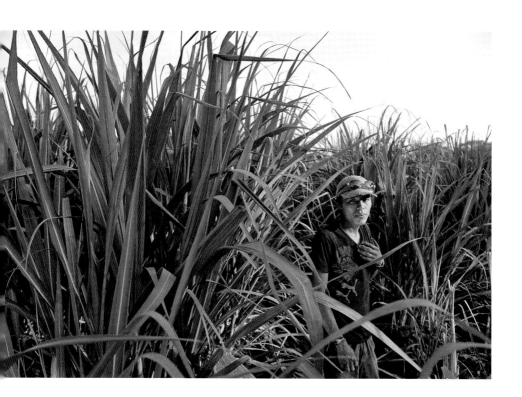

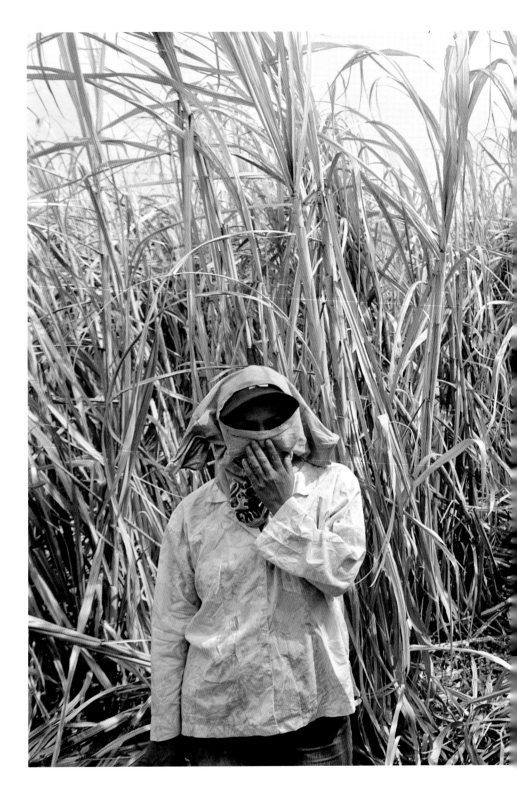

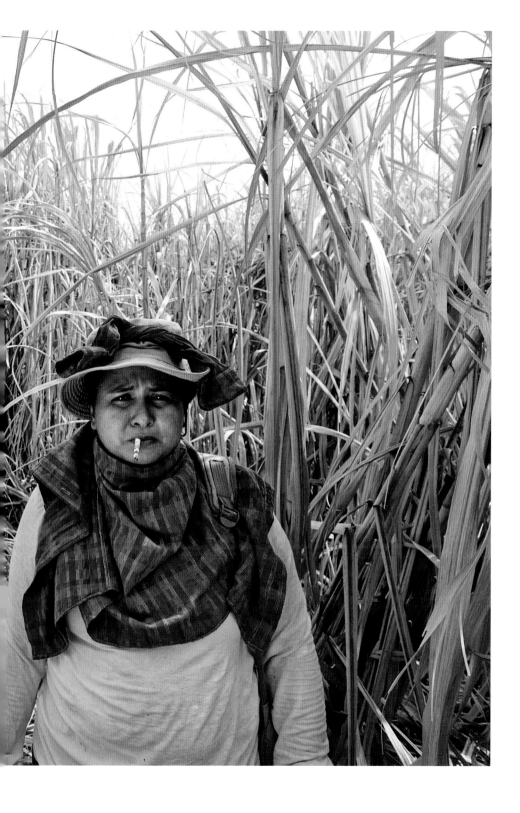

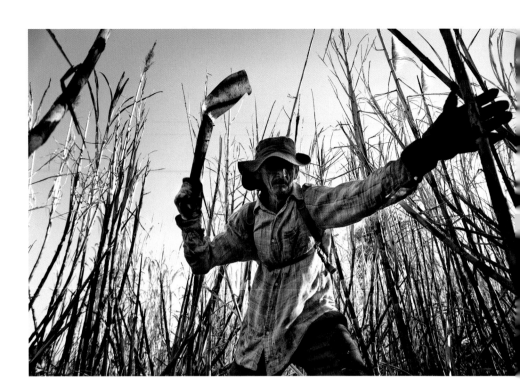

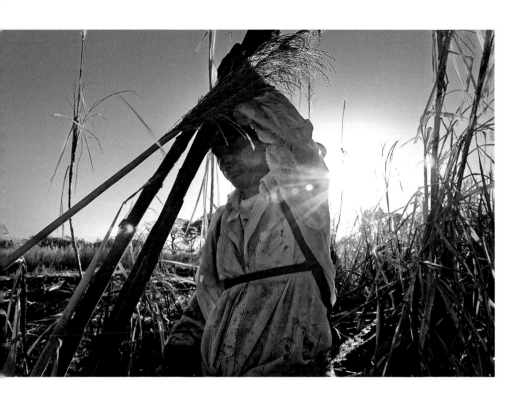

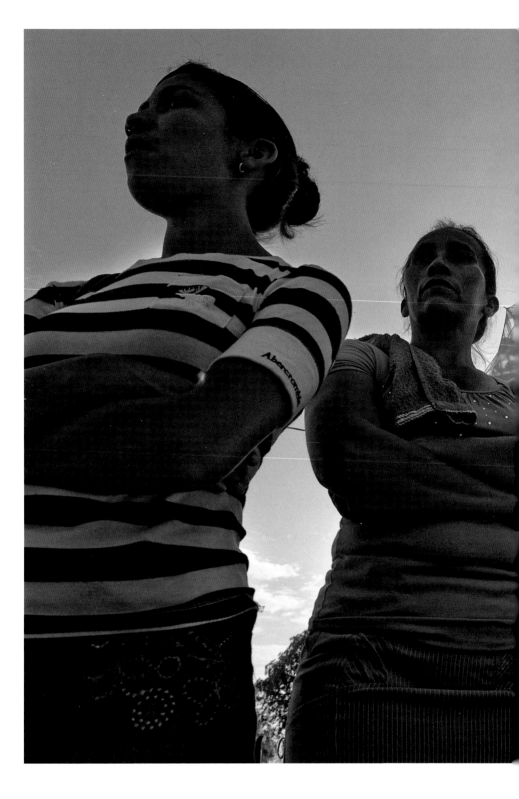

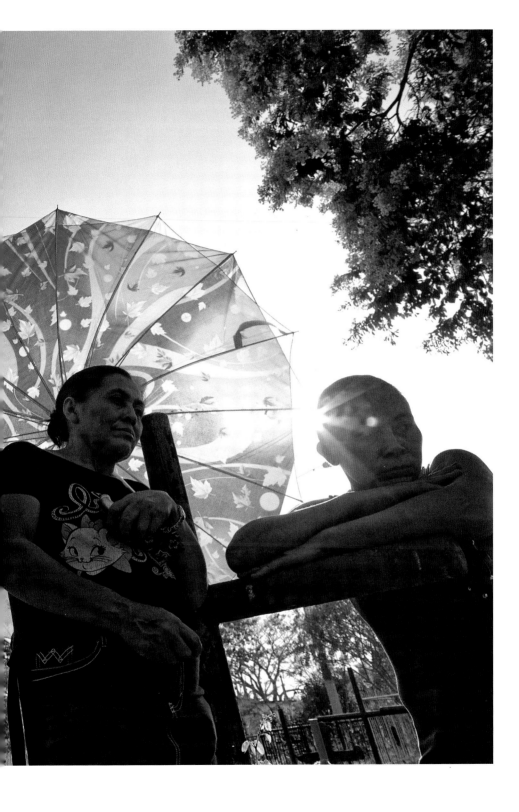

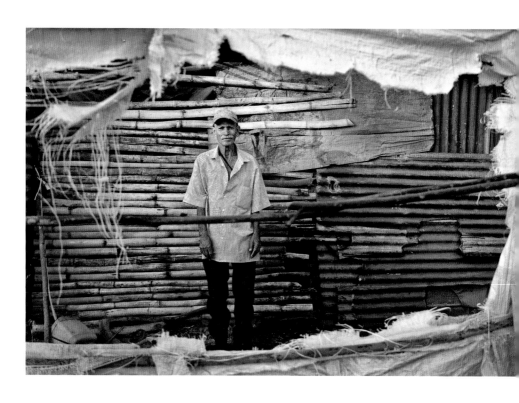

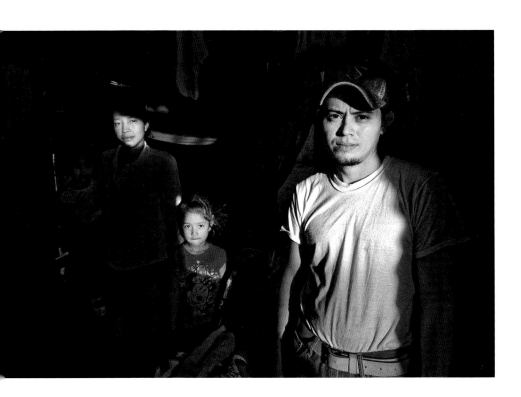

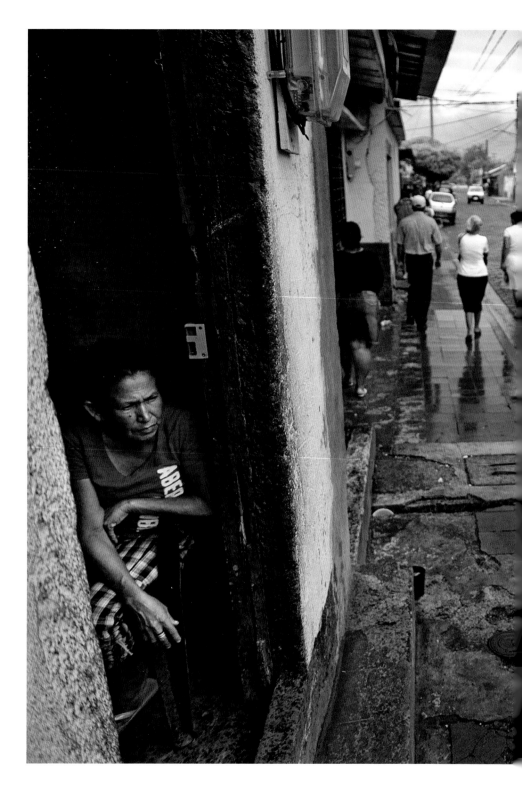

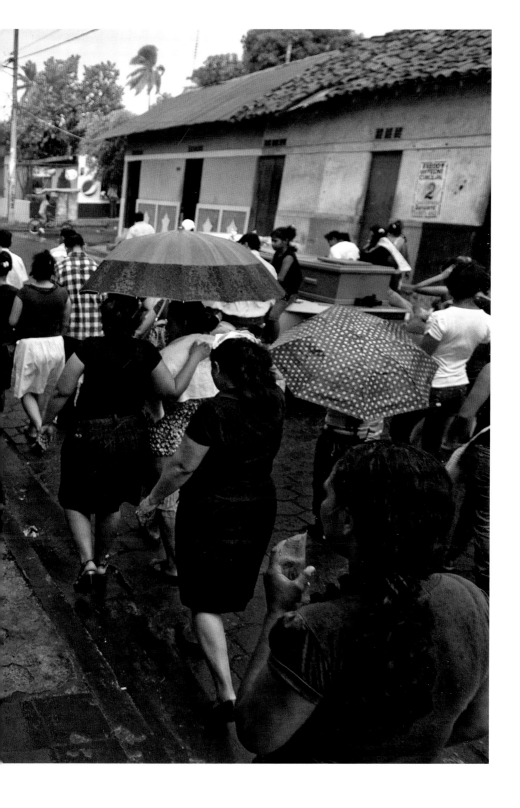

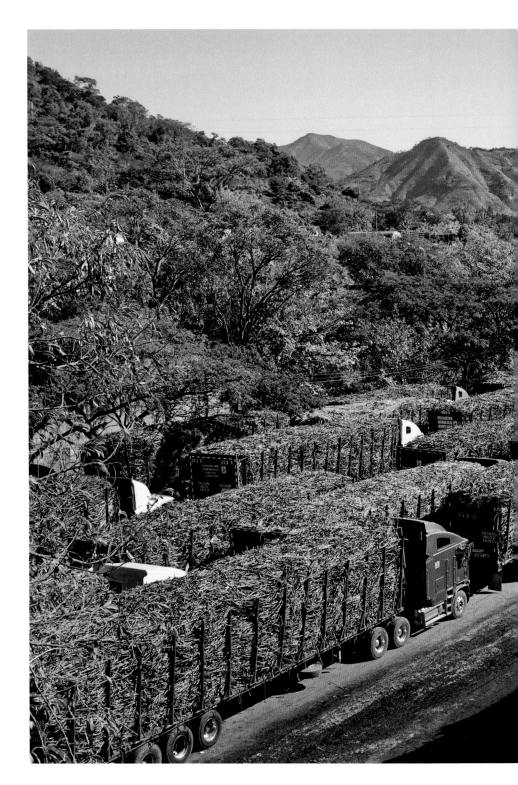

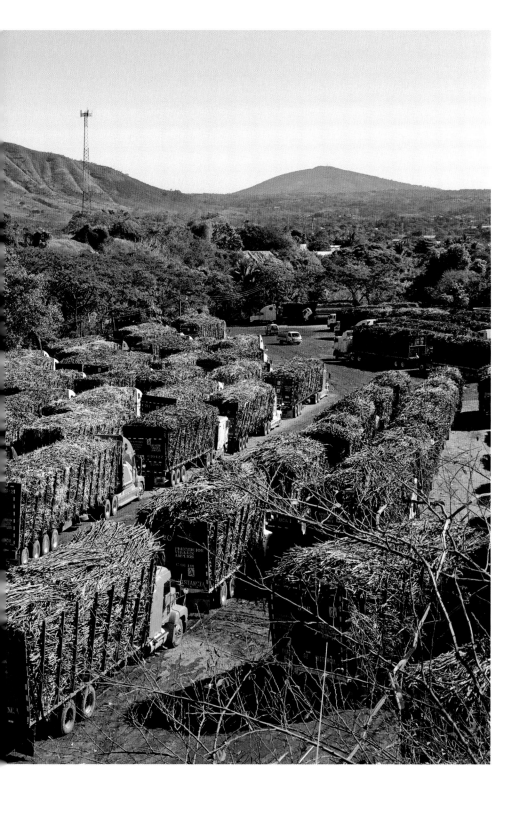

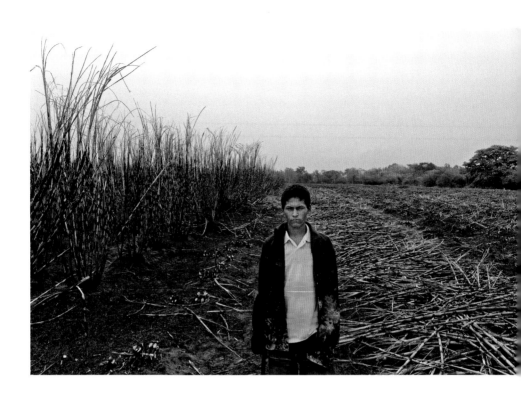

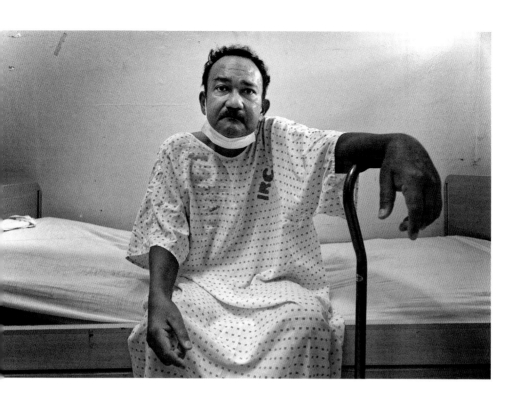

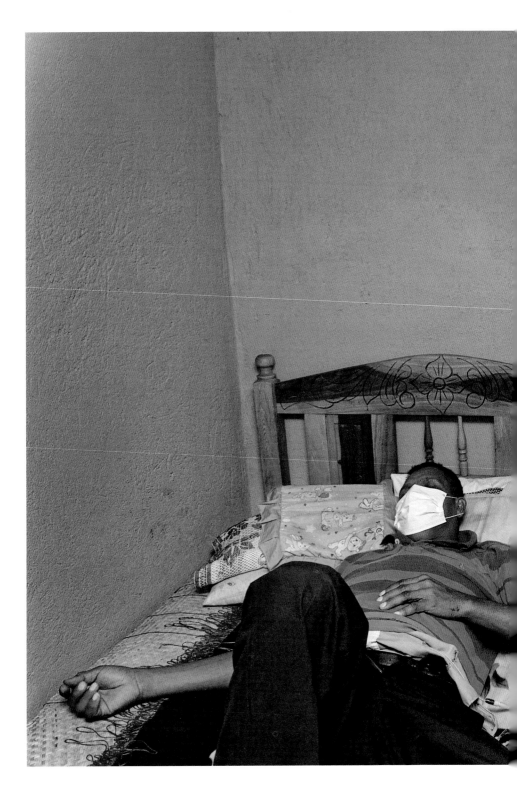

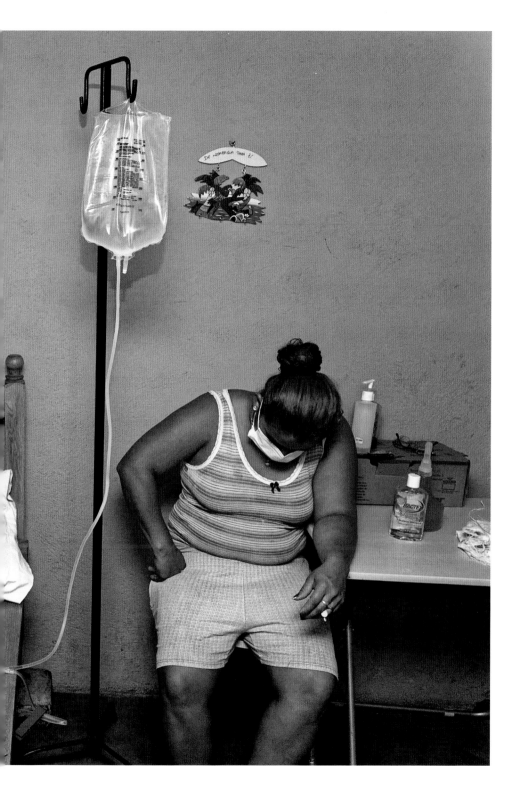

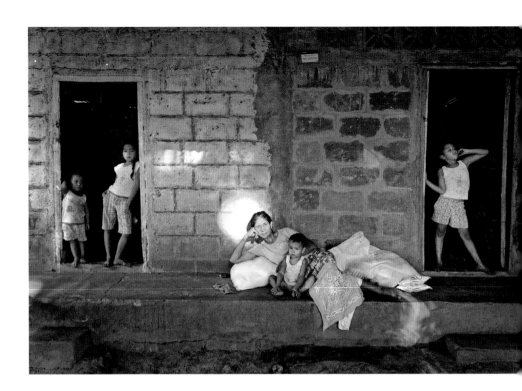

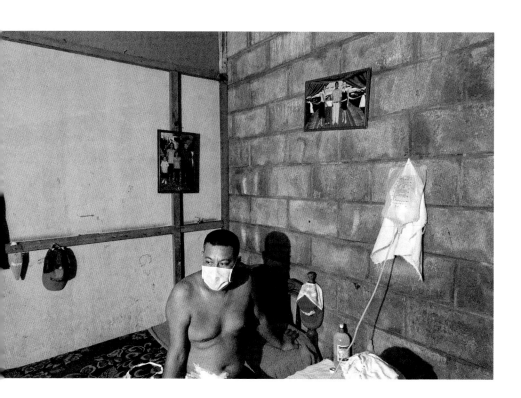

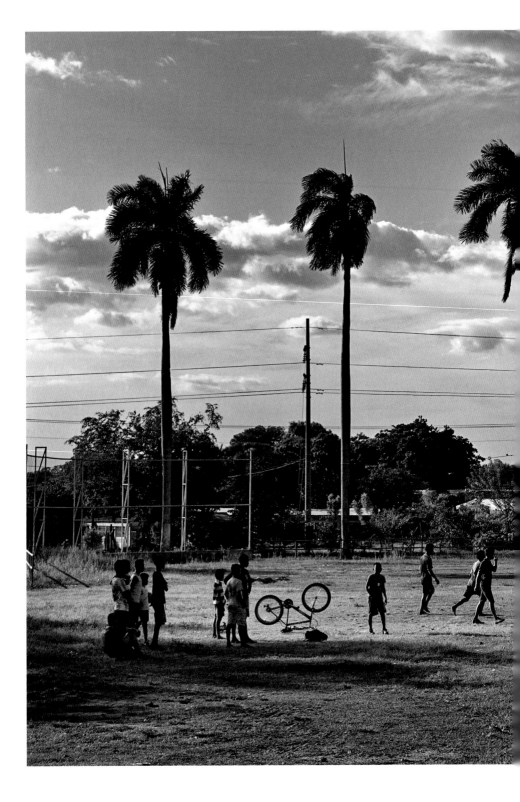

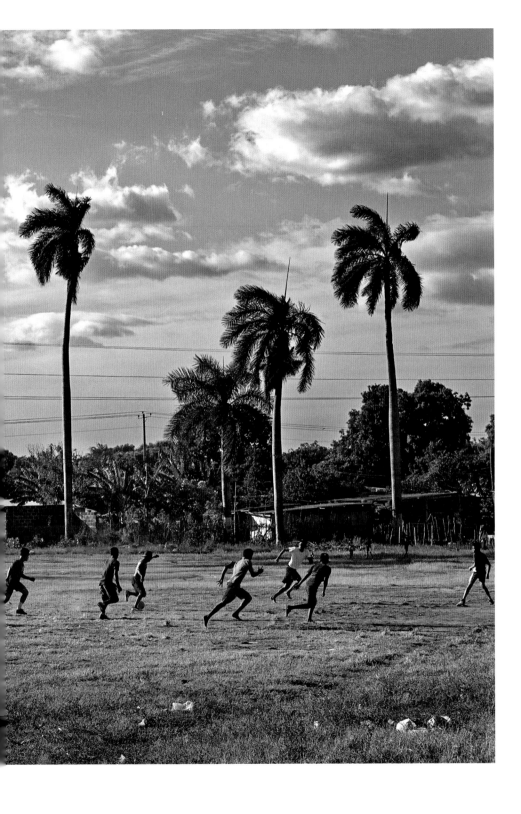

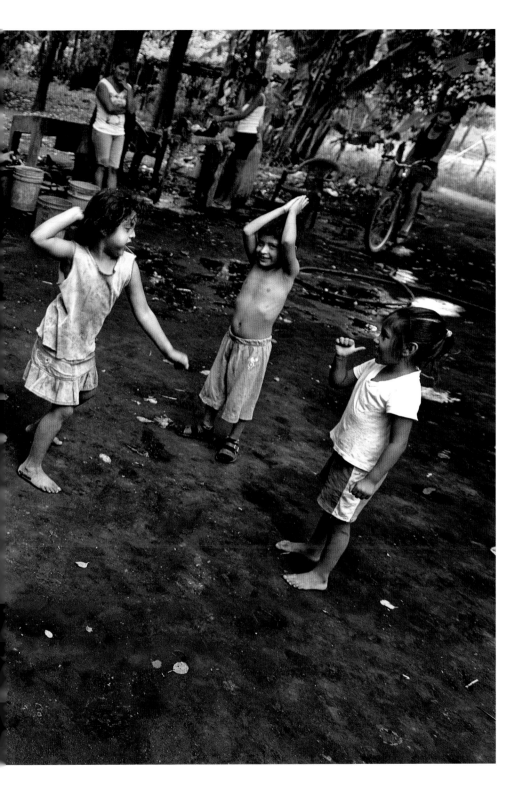

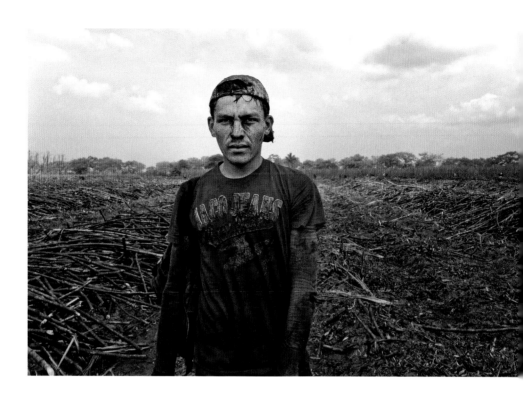

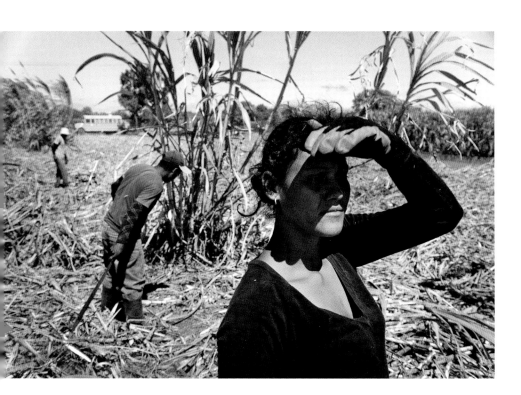

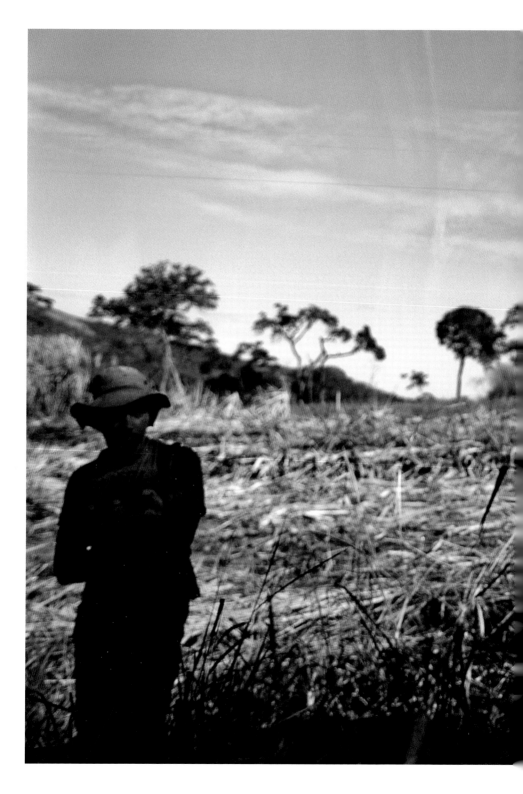

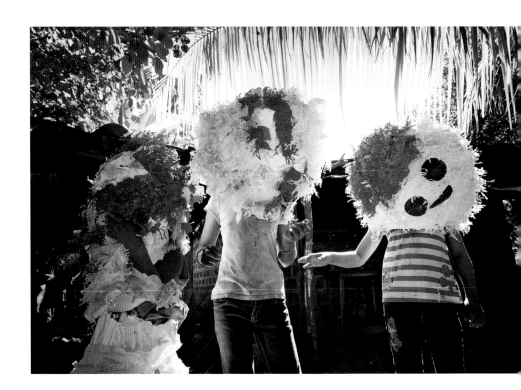

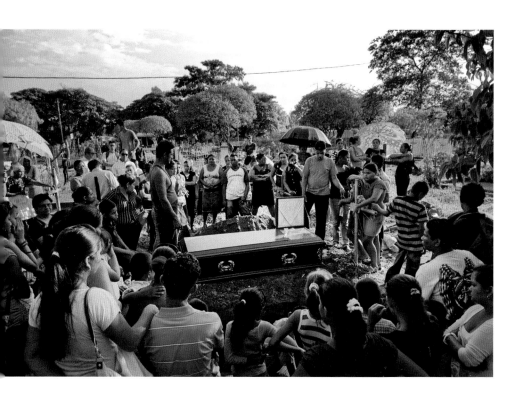

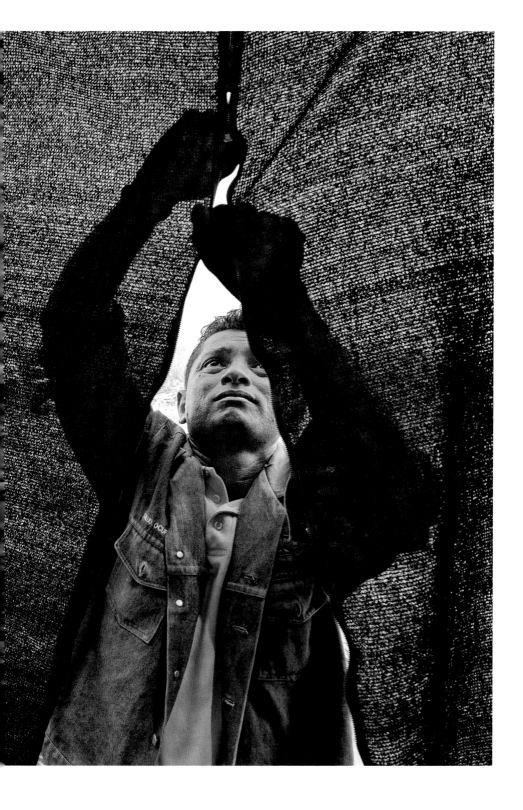

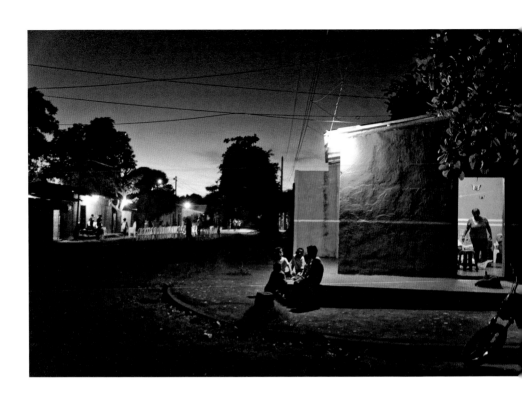

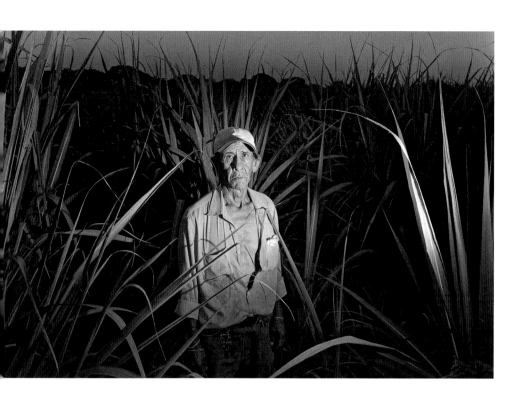

Ed Kashi

Syrian Refugees

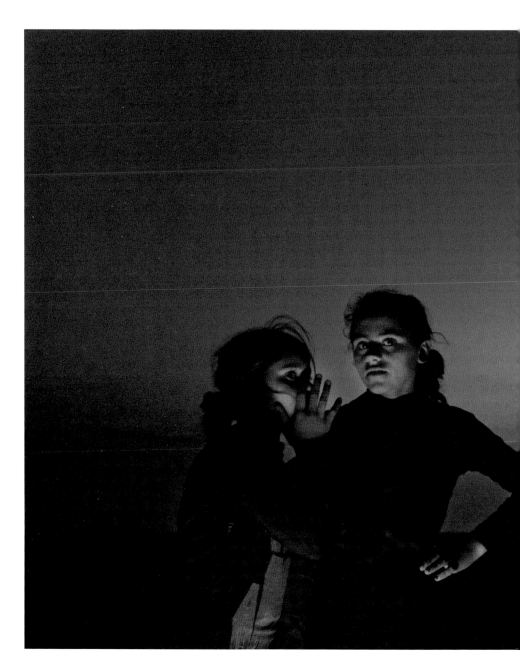

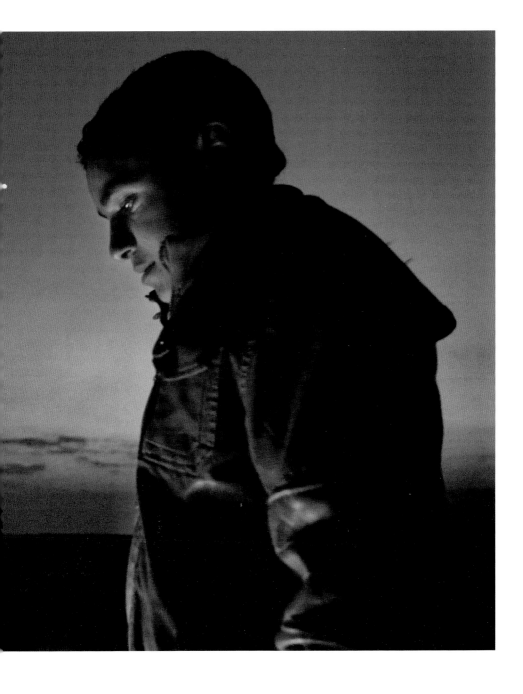

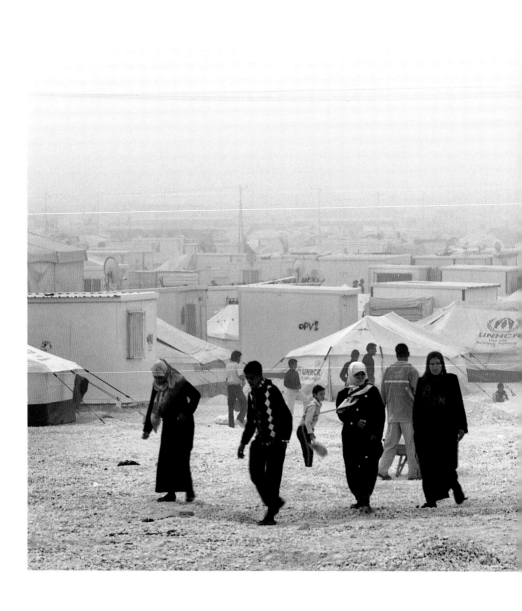

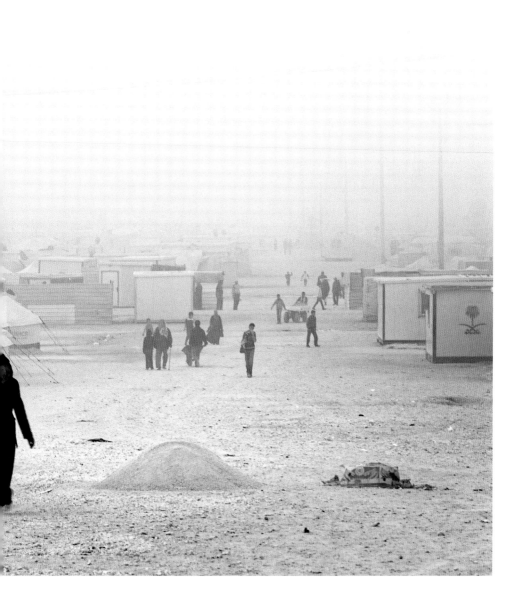

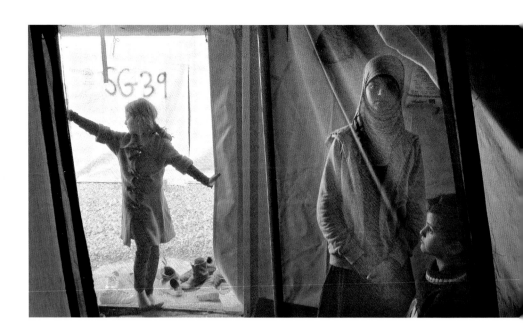

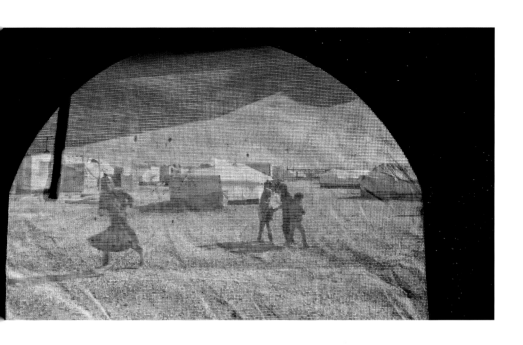

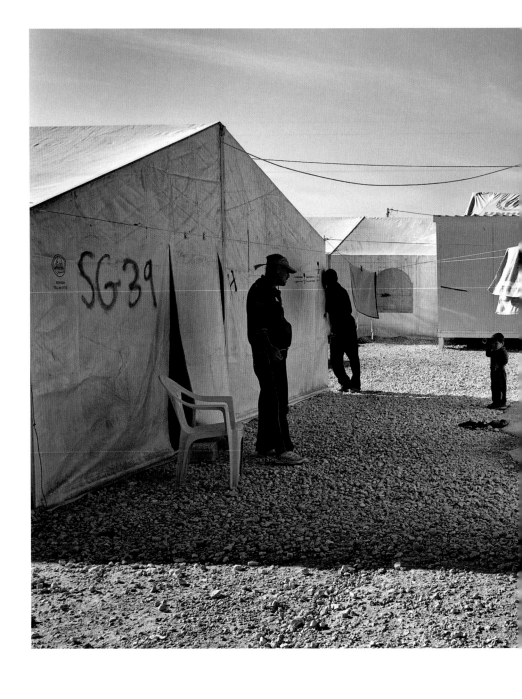

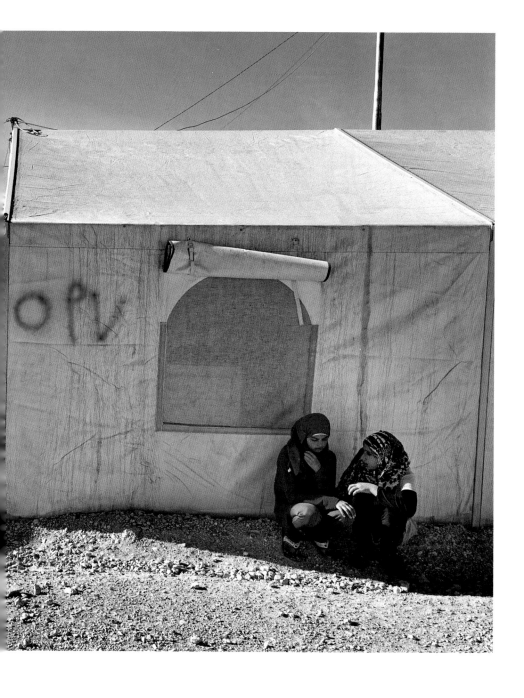

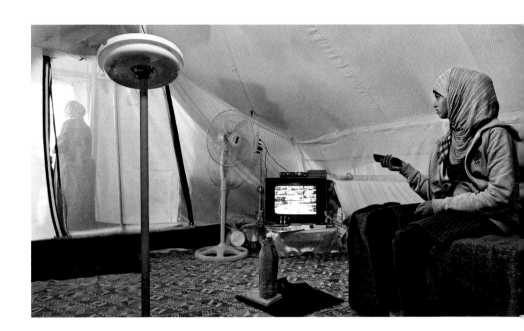

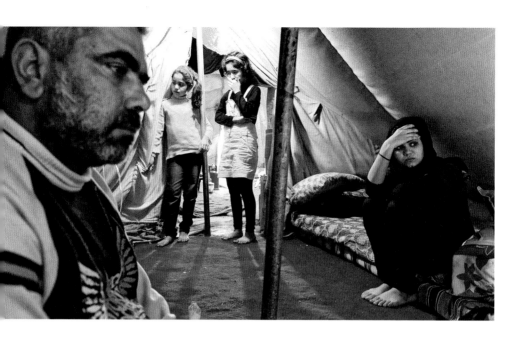

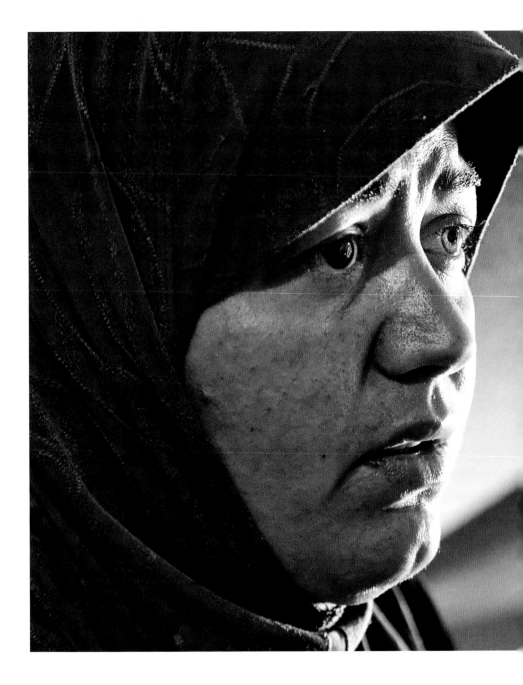

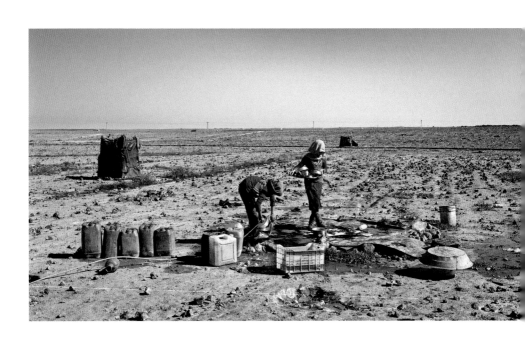

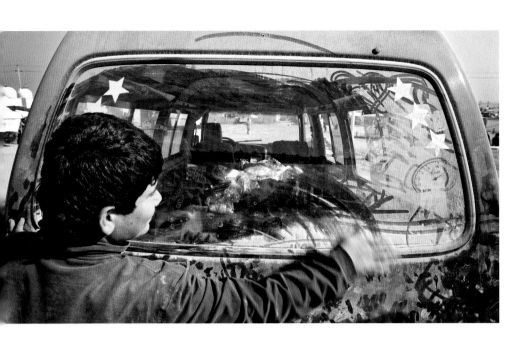

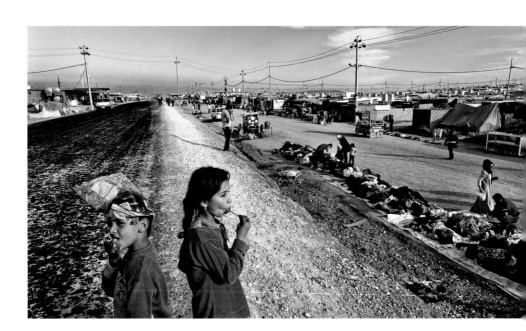

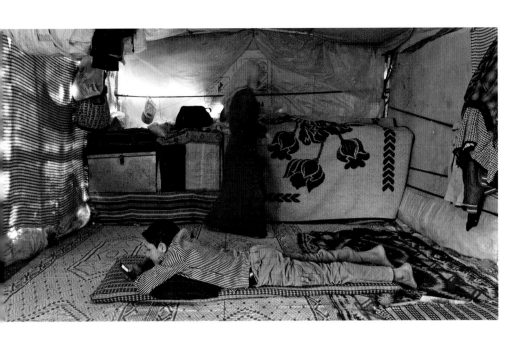

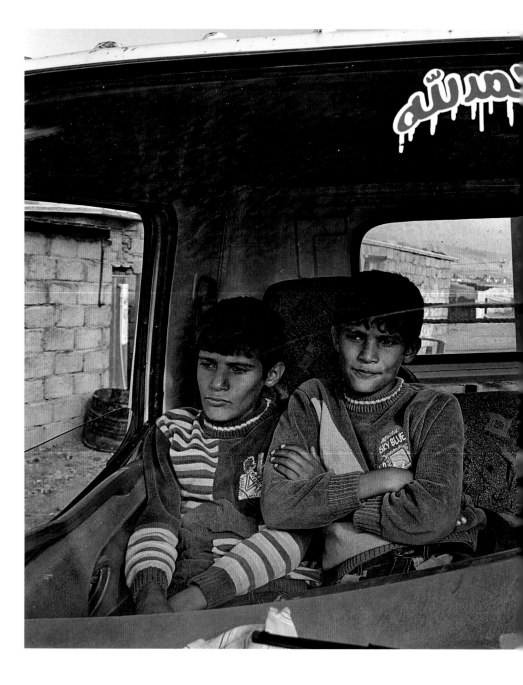

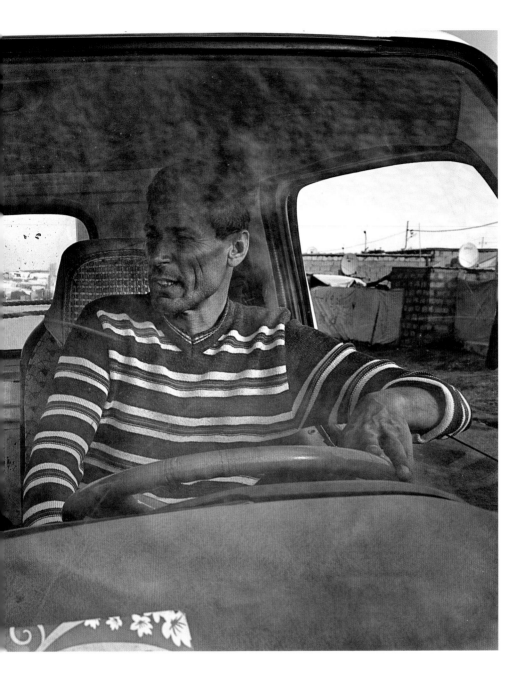

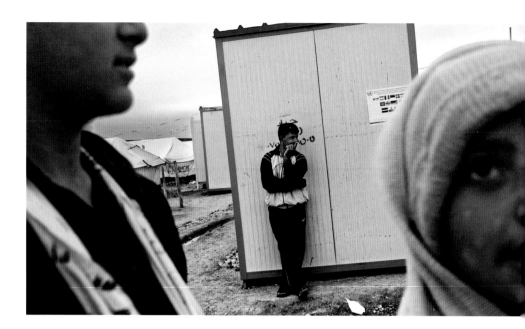

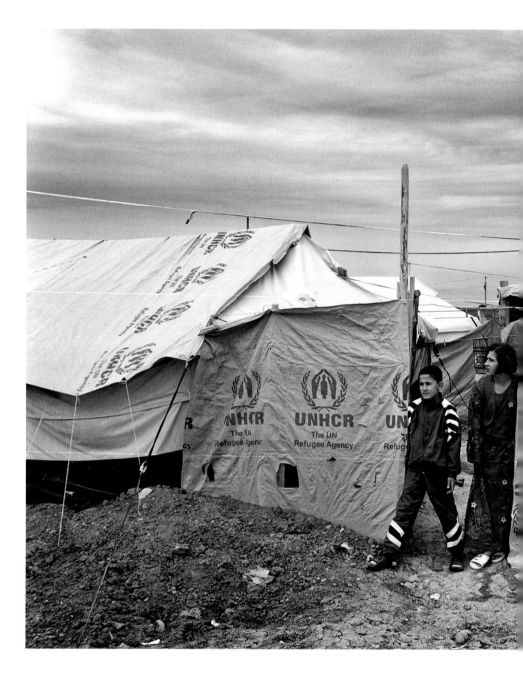

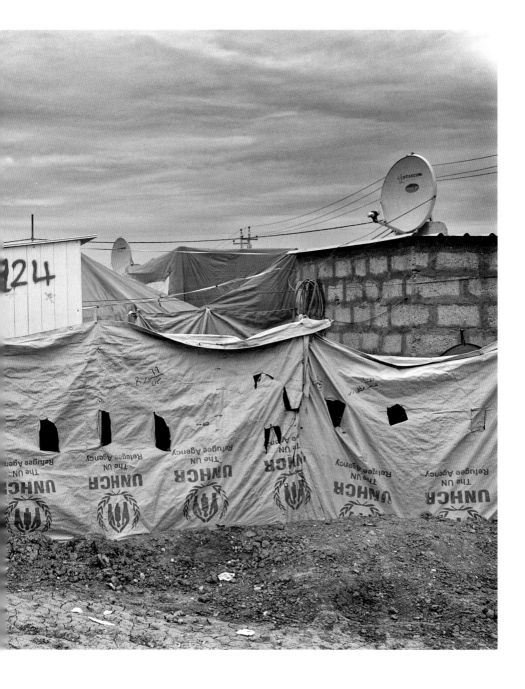

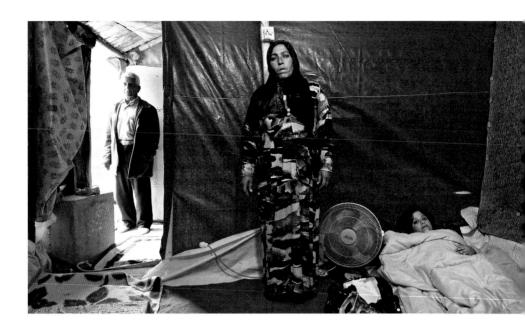

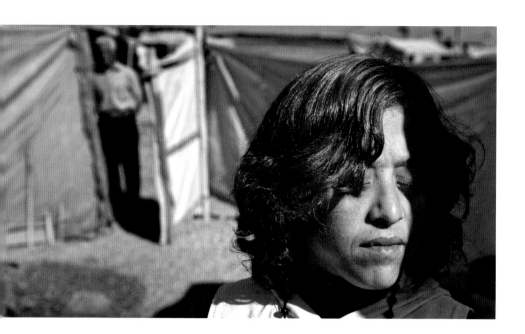

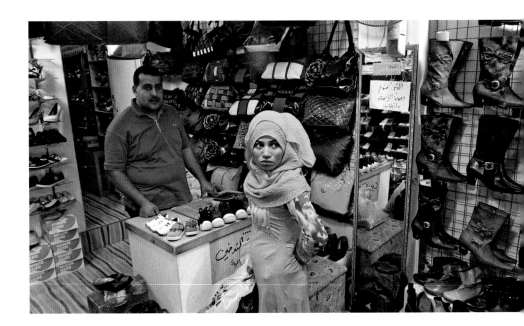

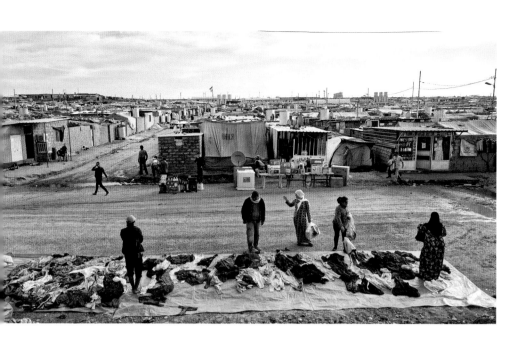

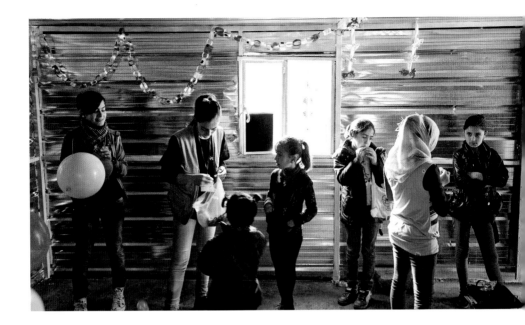

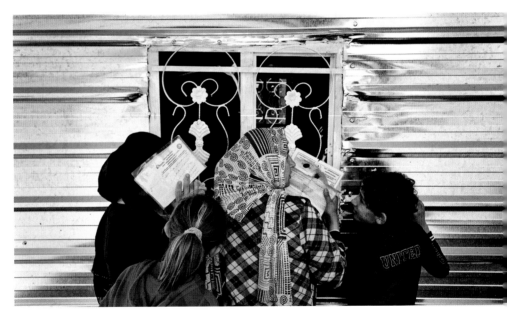

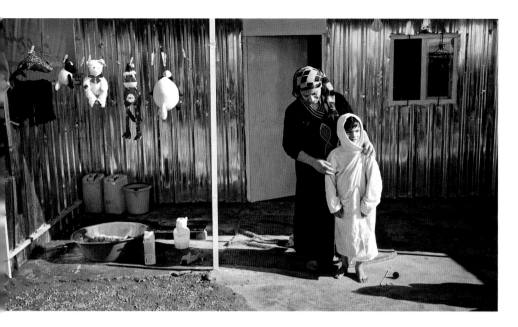

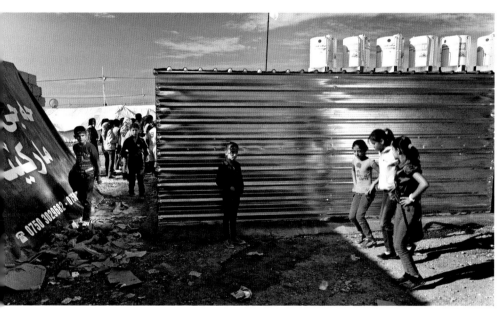

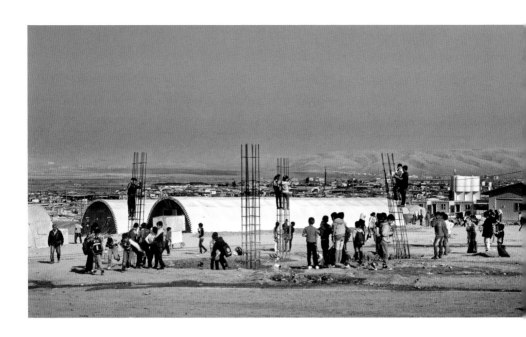

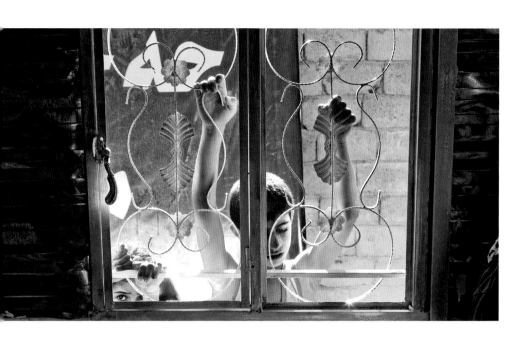

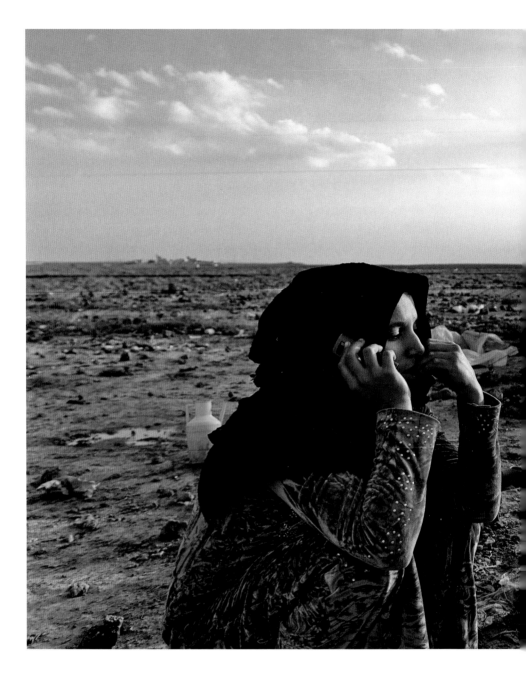

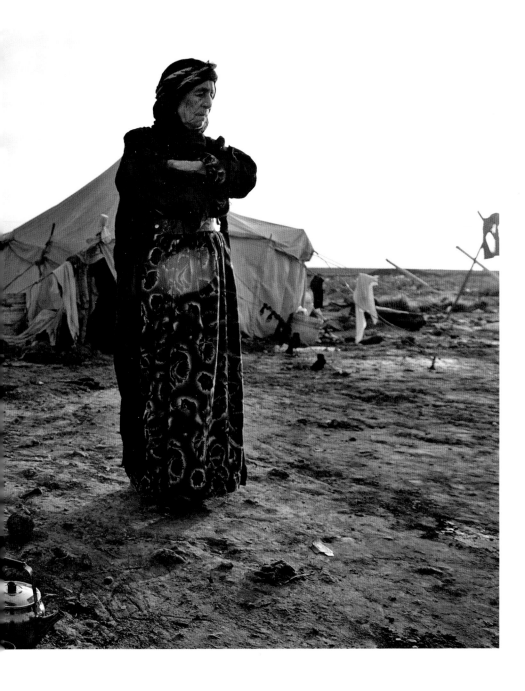

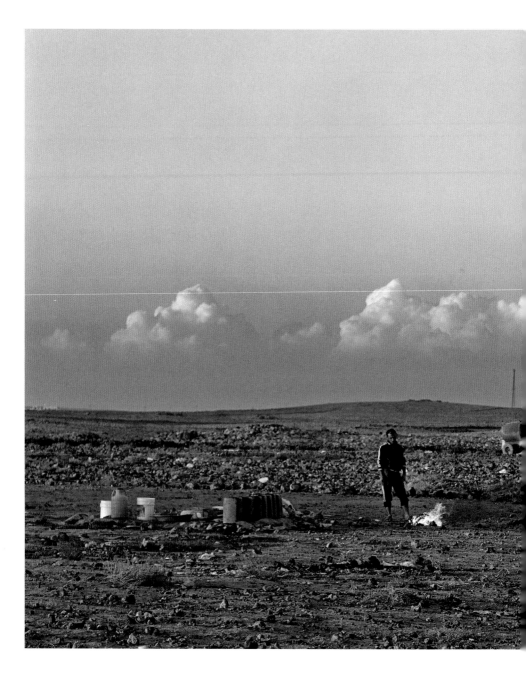

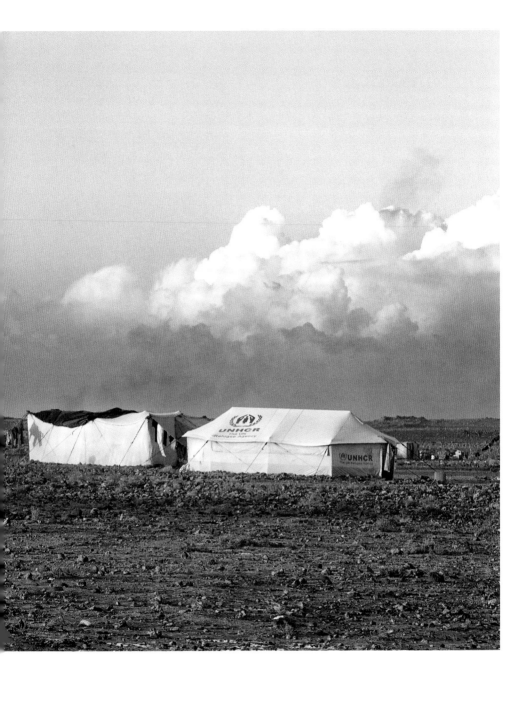

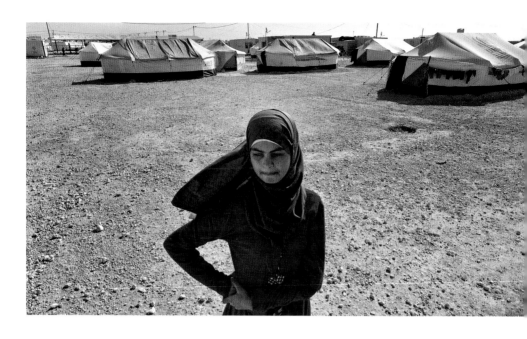

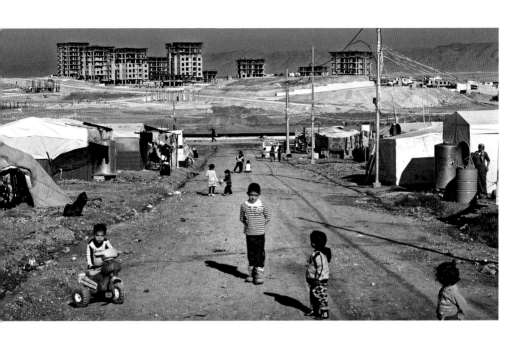

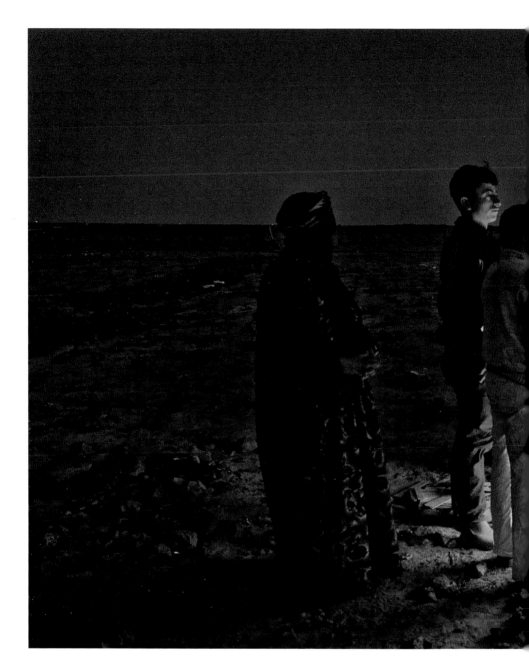

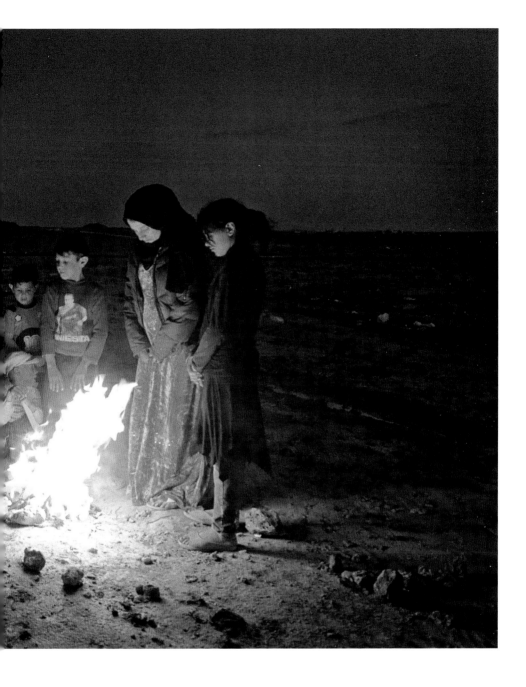

Captions

Sugar Cane

1 2015 / Nicaragua / Buses transport sugar cane workers to the fields in the early morning hours.

2 2015 / Nicaragua / Sugarcane workers line up to board early-morning buses and trucks headed for the fields.

3 2015 / Nicaragua / Sugarcane workers begin their morning commute to the fields before dawn.

4 2015 / Nicaragua / A young boy rides his bike past a field of sugarcane.

5 2013 / Nicaragua / A sugarcane worker, 29, suffering from CKDnT, poses for a portrait in the cane fields.

6 2014 / Nicaragua / A cane cutter, covered in soot and ashes from charred sugarcane, works in a field that was burned the night before.

7 2014 / Nicaragua / A cane worker slices through charred stalks of sugarcane in a field that was burned the night before.

8 2013 / Nicaragua / A widow, 53, holds a photo of her two deceased sons, whom she lost, in addition to her husband, to CKDnT.

9 2013 / Nicaragua / A cane worker, 29, and his father, a former cane worker, 58, are both sick with CKDnT.

10 2015 / Nicaragua / A quiet and peaceful morning dawns in the town of Chichigalpa.

11 2015 / Nicaragua / A former sugarcane worker, 35, suffers through the end stages of CKDnT after 15 years of working in the fields.

12 2015 / Nicaragua / A young boy, 12, tends to his ailing father, a former sugarcane worker suffering through the end stages of CKDnT.

13 2015 / Nicaragua / Family members mourn a deceased sugarcane worker.

14 2015 / Nicaragua / A young girl, 15, mourns the loss of her father, 35, a former sugarcane worker who died of CKDnT.

15 2015 / Nicaragua / Family and friends plant flowers on the grave of a deceased sugarcane worker, 35, who died from CKDnT.

16　2015 / Nicaragua / A sugarcane worker, 29, suffering from CKDnT, poses for a portrait.

17　2013 / Nicaragua / A coffin-maker, 80, poses for a portrait in his workshop. There is a death almost daily from the epidemic of CKDnT among the sugarcane workers.

18　2014 / Nicaragua / The family of a former sugarcane worker, 32, who is sick with CKDnT, spends an evening in their compound.

19　2015 / Nicaragua / Family and friends assist in the burial of a sugarcane worker, 35, who died from CKDnT.

20　2015 / El Salvador / A sugarcane worker, 19, poses for a portrait while working in the fields.

21　2015 / El Salvador / A sugarcane worker, 25, is photographed while working in the sugarcane fields of El Angel Sugar Mill.

22　2013 / Nicaragua / Family and friends gather for the funeral of a former sugarcane worker, 36, who died of CKDnT after working in the sugarcane fields for 12 years.

23　2014 / Nicaragua / A father mourns the loss of his son, 29, who died after a ten-year battle with CKDnT.

24　2014 / Nicaragua / A sugarcane worker, 29, who has just passed away after a ten-year battle with CKDnT, is laid to rest.

25　2013 / Nicaragua / Family and friends gather for the burial of a former sugarcane worker who died of CKDnT after 12 years working in the sugar-cane fields.

26　2014 / Nicaragua / A former cane worker, sick with CKDnT, poses for a portrait with his wife and daughter.

27　2014 / Nicaragua / A woman whose husband died from CKDnT is interviewed in her home in Chichigalpa.

28　2013 / Nicaragua / A young sugarcane worker is photographed at home with his wife and child.

29　2015 / Nicaragua / Men travel through the streets of Chichigalpa.

30　2015 / El Salvador / A former sugarcane worker receives dialysis in the clinic of the National Hospital, the largest in Central America.

31　2015 / Nicaragua / A nurse who attends many sick sugarcane workers with CKDnT poses for a portrait at home.

49 2013 / Nicaragua / A former sugarcane worker is photographed at the dialysis clinic of the España Hospital in Chinandega.

50 2013 / Nicaragua / A sugarcane worker's daughter helps him with home dialysis treatment at their family compound.

51 2015 / Nicaragua / A sugarcane worker with CKDnT sits with her children and their monthly food ration from the sugar mill in Chichigalpa.

52 2014 / Nicaragua / A former cane worker who has CKDnT receives a dialysis treatment at home in Chichigalpa.

53 2015 / Nicaragua / Sugarcane workers and their children play a pick-up game of soccer.

54 2013 / Nicaragua / Children play together at their home in Chichigalpa.

55 2014 / Nicaragua / A sugarcane worker poses for a photograph on the Ingenio San Antonio plantation.

56 2015 / Nicaragua / A crew of cane cutters seed a large field near the town of Viejo in Chinandega.

57 2015 / El Salvador / Sugarcane workers take a break in the fields of El Angel Sugar Mill.

58 2015 / Nicaragua / The moon casts an eerie glow over a sugarcane field.

59 2013 / Nicaragua / The children of a man sick with CKDnT play together at their home.

60 2012 / Nicaragua / Family and friends attend the funeral of a sugarcane cutter who passed away at the age of 49 from CKDnT.

61 2014 / Nicaragua / A worker closes the hydration tent on the plantation of Ingenio San Antonio.

62 2013 / Nicaragua / Friends and family set up chairs for the wake of a sugarcane worker who passed away that morning.

63 2013 / Nicaragua / A sugarcane worker sick with CKDnT is photographed in the sugarcane fields that he worked in for 25 years.

Syrian Refugees

64 2013 / Jordan / Refugee children gather by a fire near their desert camp.

65 2013 / Jordan / Refugees walk through the overcrowded Al Za'atri Refugee Camp near Mafraq.

66 2013 / Jordan / Thirteen-year-old Reem spends time with her siblings in her family tent at the Al Za'atri Refugee Camp.

67 2013 / Jordan / Children gather in an enclave of tents at the Al Za'atri Refugee Camp for Syrians.

68 2013 / Jordan / A friend talks with Reem, 13, at the Al Za'atri Refugee Camp for Syrians.

69 2013 / Jordan / Reem, 13, who suffers from mental health issues, is photographed at the Al Za'atri Refugee Camp for Syrians.

70 2013 / Iraq / Jihan, 16, sits anxiously in the family tent at the Domiz Camp for Syrian Refugees.

71 2013 / Iraq / Rihab, 37, is interviewed in her family tent at the Domiz Camp for Syrian Refugees.

72 2013 / Jordan / Syrian refugees Lamia, 13, and Sumaya, 15, wash dishes outside their tent.

73 2013 / Iraq / A refugee cleans dust off of a car in the Domiz Camp for Syrian Refugees.

74 2013 / Iraq / A young girl enjoys a lollipop while watching shoppers in the Domiz Camp for Syrian Refugees.

75 2013 / Jordan / Bilal, 14, plays on his cellphone in his family's tent.

76 2013 / Iraq / A refugee family sits in a car at the Domiz Camp for Syrian Refugees.

77 2013 / Iraq / Refugees gather at the Domiz Camp for Syrian Refugees.

78 2013 / Iraq / A man moves building materials at the Domiz Camp for Syrian Refugees.

79 2013 / Iraq / Children watch for passersby at the Domiz Camp for Syrian Refugees.

80 2013 / Iraq / Mazgen, 19, who is physically and mentally ill, rests in her tent with her parents.

81 2013 / Iraq / Mazgen, 19, takes in the sunlight outside her family tent at Domiz Camp for Syrian Refugees.

82 2013 / Jordan / Sumaya, 15, shops for clothes in a local store after her family tent was robbed at gunpoint.

83 2013 / Iraq / Refugees browse piles of clothing for sale in the Domiz Camp for Syrian Refugees.

84 2013 / Iraq / Children hang festive decorations in the Domiz Camp for Syrian Refugees.

85 2013 / Iraq / A woman dries her son after a bath.

86 2013 / Iraq / Refugees gather at the International Medical Corps facility in the Domiz Camp for Syrian Refugees.

87 2013 / Iraq / Young girls practice a dance together at the Domiz Camp for Syrian Refugees.

88 2013 / Iraq / Children climb wire pillars for entertainment in the Domiz Camp for Syrian Refugees.

89 2013 / Iraq / Refugee children peer in through the window at the International Medical Corps facility.

90 2013 / Jordan / Muna, a 16-year-old Syrian refugee, makes a phone call outside her family's tent in the desert between the Syrian and Iraqi borders.

91 2013 / Jordan / A refugee stands over a fire in an isolated enclave of desert tents.

92 2013 / Jordan / Reem, 13, spends a quiet moment alone at the Al Za'atri Refugee Camp for Syrians.

93 2013 / Iraq / Children play in the Domiz Camp for Syrian Refugees.

94 2013 / Jordan / A refugee family gathers with fellow camp residents around a fire at dusk.

About the authors

Zama Coursen-Neff is Executive Director of the Children's Rights Division of Human Rights Watch. She leads the organization's work on children's rights and co-chairs the Global Coalition to Protect Education from Attack (GCPEA). Coursen-Neff also conducts fact-finding missions and is the author of reports and articles on a range of issues affecting children, including access to education, police violence, refugee protection, the worst forms of child labor, and discrimination against women and girls. She has published on op-ed pages in major international and US publications and speaks regularly to the media. She is a graduate of Davidson College and New York University School of Law.

Ronald Grätz has worked in various capacities for the Goethe Institut in Barcelona, Moscow, Munich and Lisbon. Since 2008, he has been General Secretary of the Institut für Auslandsbeziehungen e.V. (ifa), an institute for international cultural and educational relations, and editor of the journal *Kulturaustausch – Zeitschrift für internationale Perspektiven*. Together with Hans-Joachim Neubauer, he has edited books of interviews with Carla Del Ponte (*Mein Leben für die Gerechtigkeit*), Jacques Delors (*Mein Leben für Europa*), and Ernesto Cardenal (*Mein Leben für die Liebe*) for Steidl publishers.

Ed Kashi is a photojournalist and filmmaker. He also teaches students of photography and lectures on photojournalism and documentary photography. A member of VII Photo Agency, Kashi is recognized for his complex imagery and compelling rendering of the human condition. In addition to producing seven books, he is a pioneer and innovator of multimedia and his photographic work has been published and exhibited worldwide. With his wife Julie Winokur, he is co-founder of Talking Eyes Media, a non-profit media production company specializing in socially committed projects.

Hans-Joachim Neubauer is a book author and journalist. He was editor of *Christ & Welt,* a supplement to the *Zeit* weekly newspaper, and was co-director of the Cultural Journalism program at the Berlin University of the Arts. Neubauer holds both a doctorate and a *habilitation* in literary studies, and today is a professor at Film University Babelsberg KONRAD WOLF. His book *The Rumour: A Cultural History* has been translated into seven languages. Together with Ronald Grätz, he has edited books of interviews with Carla Del Ponte (*Mein Leben für die Gerechtigkeit*), Jacques Delors (*Mein Leben für Europa*), and Ernesto Cardenal (*Mein Leben für die Liebe*) for Steidl publishers.

Kenneth Roth is the Executive Director of Human Rights Watch, one of the world's leading international human rights organizations and active in more than 90 countries. Prior to joining Human Rights Watch in 1987, Roth served as a federal prosecutor in New York and for the Iran-Contra investigation in Washington. A graduate of Yale Law School and Brown University, Roth has conducted numerous human rights investigations and missions around the world. He has written extensively on a wide range of human rights abuses, devoting special attention to issues of international justice, counterterrorism, the foreign policies of the major powers, and the work of the United Nations.

George Soros is founder and chair of Soros Fund Management LLC and the Open Society Foundations. Born in Budapest in 1930, he survived the Nazi occupation during World War II and fled then Communist Hungary in 1947 for England, where he graduated at the London School of Economics. He then settled in the United States, where he accumulated a large fortune through the international investment fund he founded and managed. Soros has been active as a philanthropist since 1979, when he began providing funds to help black students attend Cape Town University in apartheid South Africa. The Open Society Foundations today are active in more than 100 countries, and annual expenditure is some USD 800 million; they work to promote the values of open society, human rights, and transparency. Soros is the author of over a dozen books, including *The Tragedy of the European Union: Disintegration or Revival?* (2014). His articles and essays on politics, society, and economics regularly appear in major newspapers and magazines around the world.

First edition 2016

© 2016 for the photographs with Ed Kashi
© 2016 for the texts and interviews with the authors
© 2016 for this edition Steidl Verlag, Göttingen

Editor: Hans-Joachim Neubauer
Copy editor: Jeremy Gaines
Design: Sarah Winter
Image preparation: Steidl's digital darkroom
Production and print: Steidl, Göttingen
Steidl, Düstere Strasse 4, 37073 Göttingen, Germany
Tel. +49-551-49-6060, Fax +49-551-49-60649
www.steidl.de

ISBN 978-3-95829-167-6
Printed in Germany by Steidl